DIGITAL PHOTOGRAPHY Simplified

by Rob Sheppard

DIGITAL PHOTOGRAPHY SIMPLIFIED®

Published by **Wiley Publishing, Inc.** 10475 Crosspoint Boulevard Indianapolis, IN 46256

www.wiley.com

Published simultaneously in Canada

Copyright © 2008 by Wiley Publishing, Inc., Indianapolis, Indiana

No part of this publication may be reproduced, stored in a retrieval system or transmitted in any form or by any means, electronic, mechanical, photocopying, recording, scanning or otherwise, except as permitted under Sections 107 or 108 of the 1976 United States Copyright Act, without either the prior written permission of the Publisher, or authorization through payment of the appropriate percopy fee to the Copyright Clearance Center, 222 Rosewood Drive, Danvers, MA 01923, (978) 750-8400, fax (978) 646-8600. Requests to the Publisher for permission should be addressed to the Legal Department, Wiley Publishing, Inc., 10475 Crosspoint Blvd., Indianapolis, IN 46256, (317) 572-3447, fax (317) 572-4355, online: www.wiley.com/go/permissions.

Library of Congress Control Number: 2008932080

ISBN: 978-0-470-38025-3

Manufactured in the United States of America

10 9 8 7 6 5 4 3 2 1

Trademark Acknowledgments

Wiley, the Wiley Publishing logo, Visual, the Visual logo, Simplified, Read Less - Learn More and related trade dress are trademarks or registered trademarks of John Wiley & Sons, Inc. and/or its affiliates in the United States and other countries, and may not be used without written permission. All other trademarks are the property of their respective owners. Wiley Publishing, Inc. is not associated with any product or vendor mentioned in this book.

LONDON E	BOROUGH OF ORTH
9030 00000 49	023 5
Askews	20-Aug-2009
775 SHEP	£14.99
	WWX0005068/0044

LIMIT OF LIABILITY/DISCLAIMER OF WARRANTY: THE PUBLISHER AND THE AUTHOR MAKE NO REPRESENTATIONS OR WARRANTIES WITH RESPECT TO THE ACCURACY OR COMPLETENESS OF THE CONTENTS OF THIS WORK AND SPECIFICALLY DISCLAIM ALL WARRANTIES, INCLUDING WITHOUT LIMITATION WARRANTIES OF FITNESS FOR A PARTICULAR PURPOSE. NO WARRANTY MAY BE CREATED OR EXTENDED BY SALES OR PROMOTIONAL MATERIALS. THE ADVICE AND STRATEGIES CONTAINED HEREIN MAY NOT BE SUITABLE FOR EVERY SITUATION. THIS WORK IS SOLD WITH THE UNDERSTANDING THAT THE PUBLISHER IS NOT ENGAGED IN RENDERING LEGAL, ACCOUNTING, OR OTHER PROFESSIONAL SERVICES. IF PROFESSIONAL ASSISTANCE IS REQUIRED, THE SERVICES OF A COMPETENT PROFESSIONAL PERSON SHOULD BE SOUGHT. NEITHER THE PUBLISHER NOR THE AUTHOR SHALL BE LIABLE FOR DAMAGES ARISING HEREFROM. THE FACT THAT AN ORGANIZATION OR WEBSITE IS REFERRED TO IN THIS WORK AS A CITATION AND/OR A POTENTIAL SOURCE OF FURTHER INFORMATION DOES NOT MEAN THAT THE AUTHOR OR THE PUBLISHER ENDORSES THE INFORMATION THE ORGANIZATION OR WEBSITE MAY PROVIDE OR RECOMMENDATIONS IT MAY MAKE. FURTHER, READERS SHOULD BE AWARE THAT INTERNET WEBSITES LISTED IN THIS WORK MAY HAVE CHANGED OR DISAPPEARED BETWEEN WHEN THIS WORK WAS WRITTEN AND WHEN IT IS READ.

FOR PURPOSES OF ILLUSTRATING THE CONCEPTS AND TECHNIQUES DESCRIBED IN THIS BOOK, THE AUTHOR HAS CREATED VARIOUS NAMES, COMPANY NAMES, MAILING, E-MAIL AND INTERNET ADDRESSES, PHONE AND FAX NUMBERS AND SIMILAR INFORMATION, ALL OF WHICH ARE FICTITIOUS. ANY RESEMBLANCE OF THESE FICTITIOUS NAMES, ADDRESSES, PHONE AND FAX NUMBERS AND SIMILAR INFORMATION TO ANY ACTUAL PERSON, COMPANY AND/OR ORGANIZATION IS UNINTENTIONAL AND PURELY COINCIDENTAL.

Contact Us

For general information on our other products and services please contact our Customer Care Department within the U.S. at 800-762-2974, outside the U.S. at 317-572-3993 or fax 317-572-4002.

For technical support please visit www.wiley.com/techsupport.

Wiley Publishing, Inc.

Sales

Contact Wiley at (800) 762-2974 or fax (317) 572-4002.

Praise for Visual Books

"Like a lot of other people, I understand things best when I see them visually. Your books really make learning easy and life more fun."

John T. Frey (Cadillac, MI)

"I have quite a few of your Visual books and have been very pleased with all of them. I love the way the lessons are presented!"

Mary Jane Newman (Yorba Linda, CA)

"I just purchased my third Visual book (my first two are dog-eared now!), and, once again, your product has surpassed my expectations."

Tracey Moore (Memphis, TN)

"I am an avid fan of your Visual books. If I need to learn anything, I just buy one of your books and learn the topic in no time. Wonders! I have even trained my friends to give me Visual books as gifts."

Illona Bergstrom (Aventura, FL)

"Thank you for making it so clear. I appreciate it. I will buy many more Visual books."

J.P. Sangdong (North York, Ontario, Canada)

"I have several books from the Visual series and have always found them to be valuable resources."

Stephen P. Miller (Ballston Spa, NY)

"Thank you for the wonderful books you produce. It wasn't until I was an adult that I discovered how I learn — visually. Nothing compares to Visual books. I love the simple layout. I can just grab a book and use it at my computer, lesson by lesson. And I understand the material! You really know the way I think and learn. Thanks so much!"

Stacey Han (Avondale, AZ)

"I absolutely admire your company's work. Your books are terrific. The format is perfect, especially for visual learners like me. Keep them coming!"

Frederick A. Taylor, Jr. (New Port Richey, FL)

"I have several of your Visual books and they are the best I have ever used."

Stanley Clark (Crawfordville, FL)

"I bought my first Visual book last month. Wow. Now I want to learn everything in this easy format!"

Tom Vial (New York, NY)

"Thank you, thank you, thank you...for making it so easy for me to break into this high-tech world. I now own four of your books. I recommend them to anyone who is a beginner like myself."

Gay O'Donnell (Calgary, Alberta, Canada)

"I write to extend my thanks and appreciation for your books. They are clear, easy to follow, and straight to the point. Keep up the good work! I bought several of your books and they are just right! No regrets! I will always buy your books because they are the best."

Seward Kollie (Dakar, Senegal)

"Compliments to the chef!! Your books are extraordinary! Or, simply put, extra-ordinary, meaning way above the rest! THANK YOU THANK YOU THANK YOU! I buy them for friends, family, and colleagues."

Christine J. Manfrin (Castle Rock, CO)

"What fantastic teaching books you have produced! Congratulations to you and your staff. You deserve the Nobel Prize in Education in the Software category. Thanks for helping me understand computers."

Bruno Tonon (Melbourne, Australia)

"Over time, I have bought a number of your 'Read Less - Learn More' books. For me, they are THE way to learn anything easily. I learn easiest using your method of teaching."

José A. Mazón (Cuba, NY)

"I am an avid purchaser and reader of the Visual series, and they are the greatest computer books I've seen. The Visual books are perfect for people like myself who enjoy the computer, but want to know how to use it more efficiently. Your books have definitely given me a greater understanding of my computer, and have taught me to use it more effectively. Thank you very much for the hard work, effort, and dedication that you put into this series."

Alex Diaz (Las Vegas, NV)

Credits

Project Editor Sarah Hellert

Sr. Acquisitions Editor Jody Lefevere

Copy Editor Marylouise Wiack

Technical Editor Chris Bucher

Editorial Manager Robyn Siesky

Business Manager Amy Knies

Sr. Marketing Manager Sandy Smith

Manufacturing
Allan Conley
Linda Cook
Paul Gilchrist
Jennifer Guynn

Production Coordinator Erin Smith

Layout Elizabeth Brooks Carrie A. Cesavice Andrea Hornberger Heather Pope

Screen Artwork
Jill A. Proll

Proofreader Lynda D'Arcangelo

Quality Control John Greenough

Indexer Broccoli Information Management

Special Help Tobin Wilkerson

Vice President and Executive Group Publisher Richard Swadley

Vice President and Publisher Barry Pruett

Composition Director Debbie Stailey

About the Author

Rob Sheppard is the author/photographer of more than 25 books, a well-known speaker and workshop leader, and is editor-at-large and columnist for the prestigious *Outdoor Photographer* magazine. As author/photographer, Sheppard has written hundreds of articles about photography and nature, plus books ranging from guides to photography such as *Digital Photography: Top 100 Simplified Tips & Tricks*, 3rd edition, to books about Photoshop including *Adobe Camera Raw for Digital Photographers Only* and *Outdoor Photographer Landscape and Nature Photography with Photoshop CS2*. His Web site is at www.robsheppardphoto.com and his blog is at www.photodigitary.com.

Author's Acknowledgments

Any book is only possible with the help of a lot of people. I thank all the folks at Wiley for their work in creating books like this and their work in helping make the book the best it can be. I really appreciate all the work that editor Sarah Hellert did along with her associates in helping keep this book clear and understandable for the reader. I also thank my terrific wife of 28 years who keeps me grounded and focused while I work on my books. I thank the people at Werner Publications, my old home, where I was editor of Outdoor Photographer for 12 years and helped start PCPhoto magazine — I thank them for their continued support so I can stay on top of changes in the industry. I especially thank Chris Robinson, Wes Pitts, and Steve Werner for their efforts in keeping a strong magazine presence in the photo market, and a place for my work, too. That magazine work enhances and enriches what I can do for readers of my books. And I thank Rick Sammon for his support and inspiration in doing photography books.

Table of Contents

Getting Ready to Take Pictures

Set Up Your LCD for Optimum Use
Viewfinder or LCD — Which to Use?
Choose a Resolution and File Type
Choose a Memory Card
Hold the Camera for Sharpness
Choose a Program Mode
Using Your Camera's Autofocus16

2

Taking a Better Picture through Composition

Using Light to Your Advantage

See the Light
Shadows Are Important
Light Can Hurt Your Photos (What to Avoid)44
Low Front Light Can Be Beautiful
Make Textures Show Up with Sidelight
Separate with Backlight
Add Impact with Spotlight52
Turn On Your Flash When the Light Is Harsh
Time of Day Changes the Light56
Try Out Night Light

4

Understanding Exposure and White Balance

What Your Camera Meter Does
The Problem of Underexposure
The Problem of Overexposure
Correct Exposure Problems
What Is White Balance?
When to Use Auto White Balance
When to Use Definite White Balance Settings
Using White Balance Settings Creatively

Table of Contents

4	
84	4100
18	

Choosing Shutter Speed and F-Stop

Control Exposure with Shutter Speed and F-Stop	8(
Stop Action with Fast Shutter Speeds	82
Blur Action with Slow Shutter Speeds	84
Increase Depth-of-Field with Small F-Stops	86
Create Shallow Depth-of-Field with Large F-Stops	88
ISO Settings Affect Exposure Choices	9(

6

Getting Maximum Sharpness

Minimize Camera Movement	94
Focus on the Most Important Part of the Subject	96
Choose F-Stop or Shutter Speed for Appropriate Sharpness	98
Get Maximum Sharpness with a Tripod	.100
Get Sharpness with Other Camera Supports	.102

7

Getting the Most from a Lens

Get a Big View with a Wide Angle	106
Get a Tight View with a Telephoto	108
Zoom for Best Compositions	110
Choose Focal Lengths for Different Subjects	112
Closeups and Lenses	114
Focal Length and People Photographs	116
How to Buy New Lenses	118

8

Indoor and Night Light Plus Flash

Table of Contents

9

Editing and Organizing Your Photos

Import Photos to Your Computer
Organize Photos on a Hard Drive
Back Up Photos on a Second Drive
Using Photoshop Elements to Organize Photos
Using ACDSee to Browse and Edit Photos148
Using ACDSee to Organize Photos150
Edit the Good from the Bad
Using ACDSee to Rename Your Photos
Create Quick Slide Shows with ACDSee

10

Basic Adjustments with Photoshop Elements

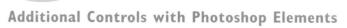

Using Selections to Isolate Adjustments
Modify Your Selections
Increase Color Saturation without Problems
Darken Specific Areas of a Photo190
Lighten Specific Areas of a Photo
Darken Edges for a Traditional Look194
Clone Effectively
What Layers Are About

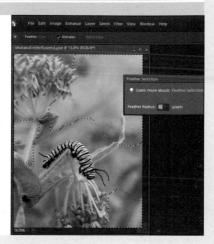

12

Printing Photos

Start with a Good Photo for a Good Print
Calibrate the Monitor
Using Photo Printers with Elements
Set the Printer Driver Correctly
Make the Right Paper Choice
Make a Good Print
Add Text to a Print

How to Use This Book

Do you look at the pictures in a book before anything else on a page? Would you rather see an image instead of read about how to do something? Search no further. This book is for you. Opening *Digital Photography Simplified* allows you to read less and learn more about digital photography.

Who Needs This Book

This book is for a reader who has limited experience with a digital camera or a photo editing program and wants to learn more. It is also for readers who want to expand or refresh their knowledge of the different aspects of digital photography.

Book Organization

Digital Photography Simplified has 12 chapters.

Chapter 1, **Getting Ready to Take Pictures**, introduces you to working with a digital camera. You learn why the LCD is so important and how you can use it to your advantage. You also learn how to set up your camera for best use when photographing.

In Chapter 2, **Taking a Better Picture through Composition**, you learn how to immediately start taking better looking photos. You learn how to simplify your images, use foregrounds and backgrounds, and how to use the rule-of-thirds.

Chapter 3, **Using Light to Your Advantage**, helps you truly see the light that makes a good photograph. You learn what to use and what to avoid, plus some tips on gaining impact with dramatic light.

Chapter 4, **Understanding Exposure and White Balance**, shows you how to get the most from your camera's exposure and white balance systems.

Chapter 5, **Choosing Shutter Speed and F-Stop**, introduces you to these key elements of photography. You learn how to stop action with the right shutter speed or how to gain more sharpness in depth with your choice of f-stop.

Chapter 6, **Getting Maximum Sharpness**, teaches you how to get the best sharpness possible from your camera and lens, regardless of the type.

Chapter 7, **Getting the Most from a Lens**, gives you extensive information about working with lenses, whether the one attached to a compact digital camera or interchangeable lenses for a digital SLR.

Chapter 8, **Indoor and Night Light Plus Flash**, shows you how to deal with the challenges of indoor and night light, from exposure to sharpness, and offers some guidelines on working with flash.

Chapter 9, **Editing and Organizing Your Photos**, gets you started working on your photos in the computer, and editing and organizing them in Photoshop Elements and ACDSee.

Chapter 10, **Basic Adjustments with Photoshop Elements**, introduces you to working with Photoshop
Elements, helping you crop images, fix problem contrast
and color, and size photos for printing or e-mail.

Chapter 11, Additional Controls with Photoshop Elements, covers selection tools which allow you to isolate your adjustments, plus their use to affect color and tone. You also learn how to clone effectively.

Chapter 12, **Printing Photos**, teaches you how to get a good print from your ink jet printer.

Chapter Organization

This book consists of sections, all listed in the book's table of contents. A section is a set of steps that show you how to complete a specific task. Each section, usually contained on two facing pages, has an introduction to the task at hand, a set of full-color screen shots and steps that walk you through the task, and a set of tips. This format allows you to quickly look at a topic of interest and learn it instantly.

What You Need to Use This Book

A digital camera

To install and run Photoshop Elements, you need a computer with the following:

- Windows: An Intel Pentium 4, Celeron, or compatible processor at 1.3 GHz or faster; Mac: PowerPC G4 or G5 or multicore Intel processor
- Windows XP with Service Pack 2 or Windows Vista operating system; Mac OS X v10.4.8 and up

- Color monitor with a minimum of 1024 x 768 resolution (a 19-inch monitor is recommended)
- 256MB of RAM (1GB recommended)
- 1.5GB of available hard-disk space (10 to 20 GB free space is recommended)
- CD-ROM or DVD-ROM drive

Using the Mouse

This book uses the following conventions to describe the actions you perform when using the mouse:

Click

Press your left mouse button once. You generally click your mouse on something to select something on the screen.

Double-click

Press your left mouse button twice. Double-clicking something on the computer screen generally opens whatever item you have double-clicked.

Right-click

Press your right mouse button. When you right-click anything on the computer screen, the program displays a shortcut menu containing commands specific to the selected item.

Click and Drag, and Release the Mouse

Move your mouse pointer and position it over an item on the screen. Press and hold down the left mouse button. Now, move the mouse to where you want to place the item and then release the button. You use this method to move an item from one area of the computer screen to another.

The Conventions in This Book

A number of typographic and layout styles have been used throughout *Digital Photography Simplified* to distinguish different types of information.

Bold

Bold type represents the names of commands and options that you interact with. Bold type also indicates text and numbers that you must type into a dialog box or window.

Italics

Italic words introduce a new term and are followed by a definition.

Numbered Steps

You must perform the instructions in numbered steps in order to successfully complete a section and achieve the final results.

Bulleted Steps

These steps point out various optional features. You do not have to perform these steps; they simply give additional information about a feature. Steps without bullets tell you what the program does in response to your following a numbered step. For example, if you click a menu command, a dialog box may appear, or a window may open. The step text may also tell you what the final result is when you follow a set of numbered steps.

Notes

Notes give additional information. They may describe special conditions that may occur during an operation. They may warn you of a situation that you want to avoid, for example the loss of data. A note may also cross-reference a related area of the book. A cross-reference may guide you to another chapter, or another section with the current chapter.

You can easily identify the tips in any section by looking for the Simplify It icon. Tips offer additional information, including tips, hints, and tricks. You can use the tip information to go beyond what you have learned in the steps.

Operating System Difference

The screen shots used in this book were captured using the Windows Vista operating system. The interface features shown in the tasks may differ slightly if you are using a Windows XP or earlier operating system, although Photoshop Elements looks essentially the same in both Windows and Mac operating systems. For example, the default folder for saving photos in Windows Vista is named Pictures, whereas the default folder in Windows XP for saving photos is named My Pictures.

Getting Ready to Take Pictures

No matter what camera you have, you can customize it so that it works really well for you. Camera manufacturers make a lot of decisions about how a camera works based on what they think photographers who might buy a particular camera will need or use.

However, manufacturers can only guess, and sometimes, the

default settings of your camera are designed for the needs of the average photographer; as a result, they are not optimal for a person who wants to take better photographs.

Is your camera set up right to support your picture taking? In this chapter, you will learn the basics of getting ready to take great pictures with your camera.

Set Up Your LCD for Optimum Use
Viewfinder or LCD — Which to Use?
Choose a Resolution and File Type
Choose a Memory Card
Hold the Camera for Sharpness
Choose a Program Mode
Using Your Camera's Autofocus

Set Up Your LCD for Optimum Use

The LCD on a digital camera is a wonderful invention. It gives you an accurate view of your subject so that you see exactly what you are going to get in your photograph. But in order to get the most from your LCD, you need to use

the camera's menus to make some choices about how it works. You want to be sure it is helping you, not holding you back. Here are some tips in setting up your camera for the best use of your LCD.

Review Time

After you take the picture, the actual image shows up on most LCDs. This image review gives you a quick look at what your photo looks like. For example, you can quickly look to see that it is sharp, and that your subject's eyes are open. You know immediately if you need to make changes to your photography.

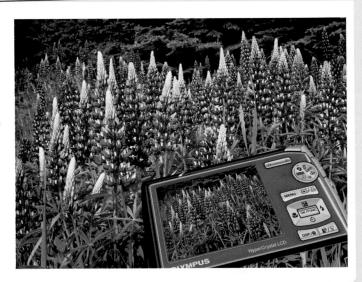

Set Review Time

On most cameras you can set review time between about 2 and 10 seconds in the camera or setup menus. Short times are not of much value because you really cannot evaluate much of what is in the picture. Try 8 to 10 seconds. Once you have seen enough, press the shutter release lightly, and the review goes away. If the time is too short, you simply press your playback button for a longer view.

Auto Rotate

Most digital cameras today automatically rotate a vertical picture so that it shows up vertically in the LCD when you hold the camera horizontally. Unfortunately, a vertical picture does not fill the horizontal space and uses the LCD inefficiently. You can get the most from your LCD and get the largest picture possible if you set the camera so that it does not auto-rotate vertical pictures. The Auto Rotate setting is usually in the playback or setup menus.

Camera Sleep Time (Auto Power Down)

A frustrating thing for digital photographers is to try to take a picture and find that your camera has gone to sleep. Most digital cameras have the auto power down time set too early. This setting is usually in the setup menu, and a good setting would be 2 to 4 minutes for most people. You can set this time longer, but then you could be using your battery more than you want to.

Viewfinder or LCD — Which to Use?

Many cameras have both a viewfinder and an LCD. Viewfinders can be either optical or EVF (short for electronic viewfinder), A viewfinder only works when you hold your eye up to it. Most people use the LCD when possible because it seems so natural to do. And some

cameras do not even have viewfinders. Why would you want to use a viewfinder compared to an LCD? There are some distinct advantages to both. Knowing the possibilities of a viewfinder can help you use your camera better.

Use the Viewfinder in Bright Light

LCDs can be hard to see in bright light, especially when there are bright subjects that you are photographing. Because an optical or electronic viewfinder limits extraneous light, and your head blocks more light, both allow you to see the subject better for framing in those conditions.

Use the LCD Inside

The LCD is ideal for shooting indoors. It has a consistent brightness, even if the light is low, which makes it easier to use than a viewfinder in those conditions. It also shows you if your exposure and white balance are correct so that you can get the best-looking image.

Use the Viewfinder for Moving Subjects

Movement can be hard to follow with an LCD held away from your face. This is where a viewfinder comes in handy. You have to have the camera up to your eyes to use a viewfinder. This makes it easier to follow movement (the camera simply follows your gaze), and distracting movement around the camera and LCD is blocked from view and not seen. Optical viewfinders are especially good for action.

OLYMPUS PRINCENSICS

Use the LCD for Close Shooting

Your LCD is showing you exactly what the lens is seeing on your camera. A separate optical viewfinder as used on compact digital cameras has its own lens system, and so it is seeing something slightly different. At a distance, this does not matter. But when you get up close, the optical viewfinder may not frame the scene correctly, which can mean that parts of your subject get cut off. You never have that problem with the LCD.

Choose a Resolution and File Type

Your camera comes with a certain resolution, such as 10 or 12 megapixels. This resolution strongly affects the price of your camera and the capabilities of the sensor. Your camera also comes with a default setting for the file type and compression that may or may not be best

for you. Understanding a little about resolution and image files will ensure that you make the right choices for the highest-quality photos. This will also mean you get your money's worth from your camera and sensor.

Find Your Settings

Resolution and file type are settings that affect image size and quality. They are usually found in the camera operation section of the menus for your camera. Unfortunately, camera manufacturers have not made the icons for these settings consistent, and so you may have to check your manual.

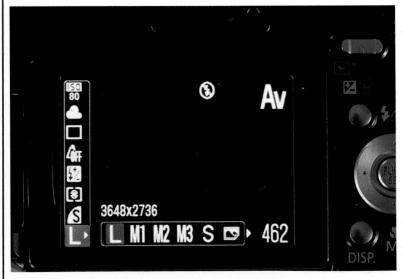

Use Your Megapixels

A common way of showing image size is L, M, and S (for large, medium, and small resolution). Large uses the full size of your camera's sensor, giving you the megapixels you paid for. Use it. Only use the smaller sizes if you really have to get small photos, such as for a Web site, and you are sure that you will never need a large photo.

Choose JPEG with High Quality

The default image type for most digital cameras is JPEG shot at medium compression or quality (quality refers to how the image is compressed for size). For optimum JPEG images, choose the highest-quality compression, such as Superfine. This makes files a little larger, but not much, and so you might need a slightly larger memory card to handle larger file sizes.

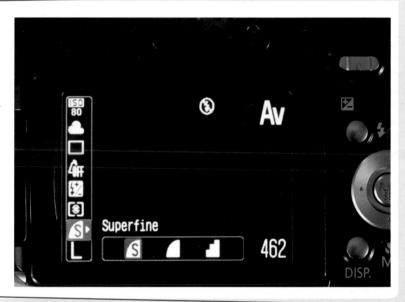

MENU RAW INFO CANCEL > MENU SELECT + CO OK

What About RAW?

Some compact digital cameras and all digital SLRs include an image type called RAW. This is a special format that saves far more tonal and color information from the sensor than JPEG offers. It is very useful for photographers who want to do extensive processing on their images in the computer. It does not have more detail than a JPEG file (that is dependent on megapixels).

Choose a Memory Card

Your camera is built to hold a certain type of memory card. A memory card stores your pictures, and you save photos to it or erase photos from it. These cards come in a variety of types such as CompactFlash or SD cards, but your camera is only designed for one type

(except for a few digital SLRs that have slots for two). While you cannot decide what type to use, you do need to decide how large a card to get and whether a certain speed will affect this choice.

Memory Card Types

You should know your memory card type so that you can recognize it in a store and be sure you have the right type. Each card type is quite different in size and shape. Open the door to the memory card slot on your camera, and take out the memory card to see exactly what it looks like (be sure the camera is off when you do this).

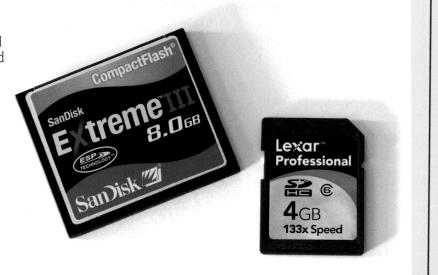

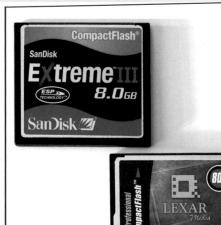

Choose Memory Capacity

Memory cards have become less expensive for more capacity. It is easy to find 1- or 2GB cards at very affordable prices. The larger the capacity, the greater the number of images you can store. Capacity is key with higher-megapixel cameras, and especially for RAW files. A 2GB card is a good starting size and will hold about 500 standard quality, full-resolution JPEGs from a 10 megapixel camera.

CHAPTER

How Important Is Memory Card Speed?

You will often see memory cards listed with speeds — 80X, 100X, and higher. This does not speed up your camera. It affects how fast images are recorded to a memory card from the camera's memory buffer. Keep in mind that not all cameras support high speeds. Speed can also affect how fast you can download images to your computer.

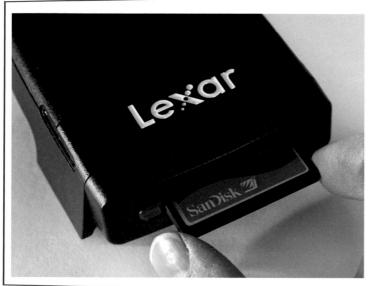

Download from a Memory Card

A simple way of downloading photos is to use your camera and the cable that came with it. A better way is to get a memory card reader. A memory card reader is usually faster, takes up little space on your desk or computer, and never has problems with battery power (if your camera loses power while downloading, you can lose your photos).

Hold the Camera for Sharpness

Digital cameras are capable of truly excellent sharpness. Yet all too often photographers are disappointed in blurry photos. They look unsharp, and people often blame "cheap cameras." Yet, the number one cause of blurriness is camera movement during exposure. How you hold the camera and release the shutter can determine whether you capture a sharp or blurry photo. This will be especially noticeable if you want to enlarge the image in a big print.

Camera Movement Causes Blurry Photos

When a camera is handheld, it can move slightly while the camera is taking the picture. As shutter speeds get slower, this means blur in your photo, and sharpness that is much less than your camera is capable of. Even if the blur is not obvious, it can still be there, degrading the contrast of the image. No amount of work on the computer can make these images truly sharp.

OLYMPIS C. 320

Support the Camera Well

Support your camera to minimize camera movement. With a digital SLR, put your left hand, palm up, under the lens, with your right hand gripping the side securely. With compact cameras, keep both hands gripping the sides solidly (no one-handed shooting!). Then keep your elbows in to the side of your chest as you photograph, in order to keep arm movement to a minimum.

Squeeze the Shutter

Holding the camera securely does not help if you punch the shutter button. Put your finger on the shutter button, and then squeeze your finger down in a smooth motion to push the button and take a picture. Keep your finger depressed as the shutter goes off, and then release it gently.

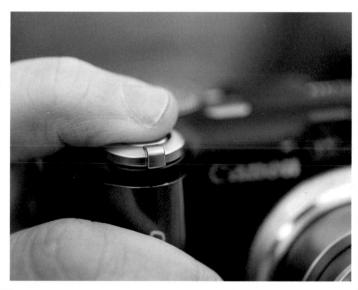

Turn Your Car Off for Sharpness

Go to any national park, and you will see people driving along, photographing from cars, bracing their arms against the frame of an open window. A moving car, combined with the vibration from the motor, always causes problems with camera movement and blurry photos. For optimum sharpness, stop the car and turn off the engine for the picture. At the minimum, avoid leaning against the car frame if the car is running.

Choose a Program Mode

Digital cameras typically have a choice of several modes of operation that affect exposure and how an image is captured. These programmed ways of operating the camera offer you options that affect how you can get the best pictures of a particular subject or scene. They are often set up for specific subjects or types of scenes so that the camera can be quickly prepared for them. By understanding a bit about them, you can quickly choose what works best for you.

Exposure Mode Choices

Cameras have to be set for a proper exposure. That includes both a shutter speed, which affects action, and an aperture or f-stop, which affects depth of field (sharpness in depth). These settings also affect how much light comes through the camera. Exposure modes change how these controls are chosen — that is, how much is done by the camera's internal electronics and how much you control.

ON SENEOS OFF ENEOS SSWF

Program, Aperture-Priority, and Shutter Speed-Priority

All digital SLRs and many small digital cameras include the modes P for Program, A or Av for Aperture-Priority, and S or Tv for Shutter Speed-Priority exposure. The camera chooses both shutter speed and aperture in P, making it good for quick shots. In A, you choose an aperture for depth-of-field, and the camera sets the shutter speed. In S, you choose a shutter speed, and the camera sets the appropriate aperture or f-stop.

Program Modes

Many popular cameras include special program modes that are designed to make decisions easier about setting up a camera for specific subjects. You will find options such as Landscape, which affects exposure, color, ISO setting, and white balance for scenic pictures; Portrait, which affects the same things for close-up shots of people; and Sports, which is designed to optimize the camera for action.

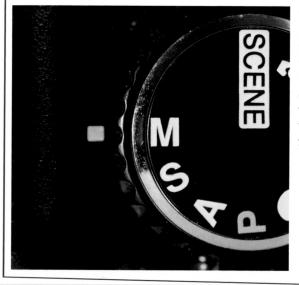

Do You Need Manual?

Manual is a mode where you set all exposure parameters yourself. Many photographers never need it, but it is helpful when conditions seem to fool all the other modes. In Manual mode, you can set shutter speed and f-stop based on how the meter works in your camera, take a picture, and then check your exposure in the LCD. If the exposure is not what you need from a scene, you can then change the shutter speed or f-stop until it is right.

Using Your Camera's Autofocus

Autofocus, or AF, is a great innovation. The camera works with the lens to determine where the lens needs to focus. AF helps your camera and lens find the right things to make sharp in your scene. That makes it easy to photograph

quickly, but AF can also focus in the wrong places. However, you can learn how to control it. A few simple techniques will help you ensure that the autofocus is finding the right part of your scene to focus on.

Focus Points Are Important

One of the most annoying things for a photographer is to have a nice picture where the focus is in the wrong place. For example, you have a great shot of grandma, but she is not sharp, though the tree behind her is. Or your beautiful flower stays blurred while the woodchip mulch behind it is sharp. Learn to look quickly at a scene so that you know which are the most important points that must be sharp.

Lock Focus on Your Subject

Once you know what has to be sharp, point your camera, set it on single-shot AF at that point, and then press your shutter button slightly to lock focus. The camera usually beeps or gives some other indicator of focus. While still pressing the shutter button, quickly move the camera to frame your shot properly, and then take the picture. Some cameras also have separate focus lock buttons.

Use Continuous Autofocus for Action

If you are photographing a sporting event such as a kids' soccer game, you usually cannot lock focus because of the continuous movement. Change your camera to continuous AF if it has that choice. Now the camera continuously focuses as you shoot the action. Sometimes the action will be too fast for it to keep up, but mostly it will keep finding the right focus as the action progresses.

Start Autofocus Early

Any AF system needs some time, however brief, to examine the scene, determine the focus point, and focus the lens. If you wait until you need that focus, especially with a moving subject, then you will often miss the shot because of this time delay. Start your autofocus early, before you need it, by lightly pressing your shutter button enough to get AF going, but not enough to trip the shutter.

Chapter 2

Taking a Better Picture through Composition

Better photos start with composition — the way you arrange the subject, background, and other parts of a photograph within the image area. Sometimes this is referred to as framing the subject or scene. Any composition is based on your decisions on what to include in the photograph, what to keep out, and how to place your subject in the scene.

What makes a composition work? This chapter will answer these questions, by showing you how to get better compositions in your photographs. You will learn about some specific techniques that you can use with your camera and on your subjects.

Simple Pictures Work Best
Get Close to Your Subject
Find a Foreground
Watch Your Background26
The Rule of Thirds
When Centered Is Good
Where Heads Belong
Watch Your Edges34
Shoot Verticals and Horizontals

Simple Pictures Work Best

A general tendency for beginning photographers is to try to get everything into one photograph. Instead of one goal for one photograph, they try to satisfy many goals in a single image. This can lead to busy, confusing photos that are not

very satisfying to the photographer or a viewer of the image. By looking to make photographs simple and direct and by more clearly knowing what you want from a photo, you will quickly create more appealing photos.

Decide What Your Subject Really Is

Does this seem like an obvious point? Although it is important, too many photographers do not really consider it. You need to know what your subject really is so that you can be sure your composition is based around it. You may also run into trouble if you include multiple subjects in a photograph, as this will confuse your viewer.

Make Your Subject the Star

A composition that does not make the subject the star of the photograph is almost always a confusing image. Your subject should never be a secondary part of a photo. If you are photographing a person, for example, photograph that person, not the person and the rest of the world around them. Do not try to include too much.

Watch Out for Distractions

Distractions take the viewer's eye away from your subject. Keep them out of your photograph. Avoid really bright spots in the background, especially high in the picture, as they always attract the viewer's eye. Watch out for signs your viewers will always try to read them. Be careful of high-contrast details that appear away from your subject, as they will draw the eye from your subject.

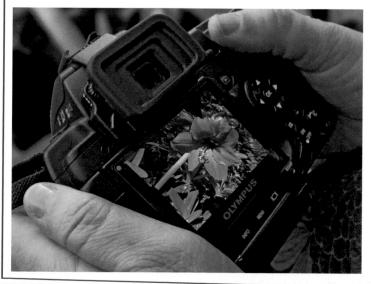

Use Your LCD Review

That LCD on the back of your camera is such a wonderful tool. It really helps with composition. Think of it as a little photograph. Do you like that photograph? Is the subject the star of that photograph? Are there distractions in the image area that are taking your eye away from the subject? Review your shot and be sure you got something that clearly favors the subject.

Get Close to Your Subject

Your subject should be the star of your photos, and one way to make that happen is to be sure you are close enough to the subject that it appears at a good size in your viewfinder. All too often, photographers step back from their subjects to get everything in, when they

should, in fact, be stepping closer to get the best shot possible of that subject. Occasionally, it looks good to have a small subject with a huge scene, but most of the time, a large subject in the frame looks best.

Watch the Space Around Your Subject

Photographers often focus so hard on the subject that they do not really see the rest of the photograph. A way to force yourself to see the whole image is to look at the space around your subject when you review the shot in the LCD. That tells you a lot about space and subjects and helps you refine your shot.

Take a Step Closer

A great technique to try is to frame up your photo to get what you think is a good shot, and then take a step closer while keeping the zoom untouched. Frame up and take the picture. That extra step often makes a more dynamic, interesting photo. It also forces you to deal with the subject differently within the image frame.

More Is Not Always Better

As noted in the last section, confusion as to what is really your subject can cause problems with your composition. This confusion often comes when photographers try to include more and more in their image. It is possible to create an interesting image with a lot of details, but it is a lot easier to create a strong photo by simplifying what you include in your photograph.

Experiment with Your Zoom

A great way of encouraging you to make a photo simple and direct is to challenge yourself with this exercise. Set your zoom to its strongest telephoto position. Then go out and take ten straight photos at that zoom position, never changing it to make a wider shot. This will make your photos look like you are close to your subject, even if you are not.

Find a Foreground

The foreground of your photo can make the difference between success and failure for a picture. The foreground is simply the area in front of your subject that is seen by your camera. Often photographers simply focus so

much on the subject that they do not even see the problems and challenges of the foreground. Foregrounds can complement a subject or they can distract and detract from it. You always have the choice.

Use the Foreground for Depth

When you have a strong foreground to your photo, the image looks deeper. A photograph is a flat, two-dimensional object that tries to reflect a three-dimensional world. A good foreground creates and defines a relationship from close to far so that your composition has a feeling of three dimensions.

Look for a Frame

A quick and easy way of using your foreground is to look for a frame that will control what the viewer sees of the subject and background. This can be as simple as an interesting tree branch across the top of the photo. Or it can be an opening in a building or a rock formation that gives a view of your subject.

Get Close and Shoot through a Foreground

You cannot always get a foreground that is sharp. You can use that challenge as an opportunity for a better photo. Get up close to that foreground and shoot through it, almost like you would shoot through a frame, but use a telephoto setting on your zoom to make the foreground soft and not sharp.

Use a Wide-Angle View and Tilt Down

Often, photographers shoot a scene with a wide-angle lens to get it all in, and then put the horizon right in the middle of the picture. Try instead to tilt the camera down so that you see the foreground better, and then move to find something interesting in the foreground that you can include in your photo.

Watch Your Background

Just like the foreground, the background can make or break a picture. Often photographers pay so much attention to the subject itself that they do not really see what is happening behind the subject. This is especially a problem with a digital SLR because the background often looks out of focus when you look through the lens, and yet changes with the actual taking of the picture. But this happens with any camera when the photographer sees only the subject.

Distracting Backgrounds Hurt Your Subject

A constant challenge that photographers face is avoiding backgrounds that distract from or fight with their subject. Watch what is happening in a background and move your camera position to avoid things like "hot spots" of light or bright colors.

Simplify a Background

A great way to keep a background subordinate to your subject is to find an angle to your subject that keeps the background behind it simple. It is hard for a simple background to distract from your subject. Without a lot of stuff behind your subject, the viewer of your picture will more clearly see your subject.

Contrast Your Subject with the Background

Another way to ensure that your subject stands out is to look for contrasts between it and the background. For example, if your subject is dark, see if you can get something light behind it, or find a color that is distinctly different than your subject.

Place Your Background

Even if you cannot get close to your subject, you can often make it stand out by placing your background carefully behind it. Find a bright spot, and then move so that the subject is in front of it. Or find a strong color and then move so that it sits behind your subject.

The Rule of Thirds

Over the years, a number of compositional "rules" have been developed by artists and photographers to make good composition easier. A good one that is easy to use is the rule of thirds. This is so popular that some cameras can even display superimposed lines

over the scene that match the rule of thirds. You do not always have to use the idea of a rule of thirds, though, because the world does not always fit it. However, it is a good place to start for placing things in a photo.

Divide a Photo into Horizontal Thirds

In your mind, draw imaginary horizontal lines across the image in your viewfinder or on your LCD that divide the photo into thirds. Use these lines to position your horizon or any other strong, horizontal line. This helps get your horizon out of the center of the image, which is a poor place for most horizons.

Divide a Photo into Vertical Thirds

Again, draw imaginary lines across the image in your viewfinder or on your LCD, but now use vertical lines that divide the photo into thirds. Use these lines to position strong vertical elements, such as trees or tall buildings. These are effective compositional places for this type of subject matter.

Use the Intersections

If you consider both the horizontal and vertical lines at once, you will find that you have four points where the lines intersect. These are great locations for your subject. These positions create interesting visual relationships with the rest of the photo, so you need to look at the rest of the photo beyond just placing your subject. That "rest" of the photo affects what the whole image looks like.

Rule or Guideline

The real world, or your view of the world, does not always fit the rule of thirds, in which case you should not force the composition into thirds. However, it can be a guide for how you place your picture's elements within the photo. It will especially help you get some variety in your pictures so that your subject is not always in the center.

When Centered Is Good

You may get advice from seasoned photographers to keep your subject out of the center of the picture. This is certainly a reason for the rule of thirds and it is good advice ... most of the time. However, if you always keep the subject out of

the center, you limit your options for composition. If you make a deliberate decision to either keep the subject in the center or not, then you are more likely to find a good place for the subject in your composition.

Create a Bold Center

Some subjects have a strong center with radiating lines that all point to the center. You can use that center in a composition by putting it right in the center of your picture, and then getting in close. You need to get in close enough so that all extraneous details that do not relate to the center and its supporting lines are kept out of the photograph.

Find a Balanced Composition

You will find some subjects that simply have a balance between top and bottom or side to side. Find a way to emphasize that balance by putting a center found in the subject in the middle of the photo. For example, if the subject is balanced left and right, put the subject so that it is centered in the photo in the same way, left to right.

Balance Night and Day

There is a point in the sunset where the sun is right at the horizon. This is truly a balance point between night and day. You can put the horizon and the sun right in the middle of the picture if the top and bottom have detail to support the composition, such as a water scene. Otherwise, put the sun in the middle from left to right, but at the bottom of the photo so that the sky is emphasized.

Look for Patterns

Patterns that work from the center can be fascinating for a composition. Sometimes the subject has naturally concentric patterns, such as a snail's shell, but other times those forms come from the way you line up objects in a scene. These can all make fascinating photographs.

Where Heads Belong

People take pictures of people — such as friends, family, and people in groups. People are shot as portraits to remember someone, as candid shots from events, as parts of a larger scene, and in many other types of images. Sometimes these are single-person shots, while

others are shots of families or teams. People as subjects are one of the most common reasons for taking a picture. You can get better people pictures by paying attention to where you place their heads.

Keep Headroom Tight

You will often see people pictures with the heads centered in the photo and a big space over their heads — too much headroom. Unless there is a good reason for putting space over a head (such as a frame being there), keep the space tight and to a minimum, but without touching the head to the top of the image area.

Crop a Head to Show a Face

You may notice that a dramatic effect often used by television news is to crop into the head of someone being interviewed so that you cannot see the top of their head. This forces the viewer to look at the person's face, their expression, and their eyes, rather than just seeing an outline of the head.

Keep the Back Row of Heads Close to the Top

Parents rush out to find and photograph their kids after an event, and often want to include a whole group of people. But then they put a lot of headroom above the top of the back row, shoving the whole team into the bottom of the photo. A better approach is to tilt the camera down so that the back row of heads is close to the top of the picture.

Center a Close Portrait Left and Right

When you get in close to a subject, you will often find that it looks best when balanced left and right. You do want to keep headroom tight at the top, regardless of whether the subject is a person, a cat, or even a flower. By balancing the photo left and right, you make sure the viewer really looks at the subject rather than the composition.

Watch Your Edges

It is easy to get so caught up in your subject and making sure it looks right that you forget to look at the edges of the picture. However, those edges can be extremely important and will affect how viewers look at and perceive your photograph. Sometimes those edges can cause major problems when they include elements that do not belong in the image. You need to have edges that work with, not against, your photo.

Scan the Edges for Distractions

Distractions, such as branches, feet, hoses, and cords, often creep in uninvited along the edges of a photograph and call attention to their presence. Check edges regularly, including in playback on the LCD, and watch for distractions that need to be kept out of the photo.

Create a Photo with All Detail on the Edges

One way to really learn to watch the edges is to actually do a little exercise with the edges of the photograph. Try giving yourself an assignment to take ten pictures that not only keep the subject out of the center of the photo, but also only have important detail along the edges of the picture.

Lead the Viewer in from the Edge

You will often find scenes that you can compose with something coming from the edge of the photo, such as a stream, that progresses into the image area in such a way that it draws the viewer's eye in as well. Curving lines can be particularly effective and pleasing when they do this.

Deliberately Crop a Subject at the Edge

The French impressionist painter Degas was famous for his paintings of ballerinas, where he deliberately cut off figures right at the edge of the frame. Photographers often get subjects touching the edge inadvertently. That creates a weak composition. Strength can come from really looking and thinking about an edge and how it affects the scene.

Shoot Verticals and Horizontals

Cameras are made to shoot horizontally. Many cameras are even awkward to hold any other way. So it is no surprise that verticals are not as easy to do, and so, of course, they are not done as often. Yet the world is both vertical

and horizontal, so why should your photographs not reflect that? In addition, when you have both vertical and horizontal photographs of your subject, you know that you are looking for better ways of capturing that subject.

Experiment with Holding a Camera Vertically

In order to get vertical photographs, you have to be comfortable with holding your camera vertically. If it feels too awkward, you will not do it. Try turning the camera vertical and think about how it feels. Discover the best way for you to hold the camera vertically. Find the easiest way for you to reach the shutter, even if you have to use a different finger than normal.

Shoot Vertical Subjects Vertically

This may seem obvious, but cameras have such a strong horizontal orientation that many photographers just give into that orientation, no matter what the subject looks like. Just remember to think vertically with vertical subjects.

Shoot Vertical Subjects Horizontally

Once you start shooting vertically, though, it is easy to forget to do horizontal shots. This is important because your photos will start to look a bit boring if you shoot all horizontal subjects horizontally and all vertical subjects vertically. The point is to mix it up a bit, but to be sure that verticals get both horizontal and vertical coverage.

Shoot Horizontal Subjects Vertically

Something that very few photographers do is to shoot horizontal subjects vertically. It can be hard to do, but it can also create interesting photos that are very graphic and even abstract. When you start trying to place horizontal subjects in a vertical photo, you have truly arrived at looking for both vertical and horizontal compositions.

Chapter 3

Using Light to Your Advantage

Light — it is what makes photography work. Without light of some sort, you cannot take pictures. But light is not some absolute, unchanging thing. Light can be strong or weak, colorful or dull, contrasty or flat. Light changes as you change your angle to a subject, or change the time of day that you shoot.

In this chapter, you will learn to literally see the light on your

See the Light
Shadows Are Important42
Light Can Hurt Your Photos (What to Avoid) 44
Low Front Light Can Be Beautiful
Make Textures Show Up with Sidelight48
Separate with Backlight
Add Impact with Spotlight
Turn On Your Flash When the Light Is Harsh 54
Time of Day Changes the Light
Try Out Night Light

See the Light

Beginning photographers concentrate so much on the subject that they do not always see other things, such as the light on the subject and its surroundings. That light can be more important than the subject itself because the wrong light can make the subject almost disappear from view, while the right light can make that subject the star of your picture. Start "seeing the light" and you will find immediately that your photos get better.

Where Is the Light?

Start by forcing yourself to go beyond putting the subject into your picture. Make yourself look at the light. Where is the bright light? Where are the dark areas? Is the light where it needs to be in order to make your subject look its best?

Watch Both Subject and Background Light

You saw how important the background was in the last chapter. It continues to be important with light. A problem often arises when the light on the background wants to compete with the subject. Always remember that a viewer's eyes are attracted to bright areas in a background.

Notice Highlights and Shadows

Light is about bright areas and shadows. You must look at both types of light on the subject and background. Bright lights can help a subject, or they can create harsh contrast where it is unwanted. Shadows can set off a subject, or they can add unwanted contrast.

Use Your LCD Review

You probably have noticed how important that LCD is for getting better photos. The LCD can really help you see the light. Our eyes see light differently than the camera. Therefore, you can get fooled if you are only looking at the subject as you photograph it. Check that LCD review to see what the light really looks like in your picture.

Shadows Are Important

Shadows are critical to a good photograph, and they only appear with the light. Shadows can be gentle and open in their tonalities so that detail appears throughout them. They can also be hard-edged and dramatic while hiding detail within them. Either way can be both good and

bad for your subject, depending on what the shadows actually do and where they fall. The worst thing is to have shadows make your subject less visible in a photograph. Seeing the light also means seeing the shadows.

Shadows Are an Important Part of Light

Photographers just learning about light can concentrate so much on seeing the light that they do not see the shadows. Yet shadows are as much a part of any light as the bright areas in a photo. Start looking at your subject in terms of both the light and shade, and how both can either make or break a picture.

Shadows Can Make Your Subject Stand Out

Very often, you can move around your subject so that shadows appear in the background and make that subject stand out. Shadows usually give a tonal or brightness contrast that helps the viewer of your picture to see the subject better. Even a small piece of shadow behind a bright spot of your subject may help.

Shadows Can Be Distracting

When shadows fall across your subject, watch out. The photo can become unusable. This is one place where an overemphasis on the subject can really hurt your photo. If you see the subject and photograph what you "see," it is easy to miss how cross shadows or just shadows in the wrong places can make a good-looking subject look bad.

Shadows Can Make Interesting Photographs

Shadows themselves can be a great subject. Shadows make interesting patterns all around us, and a photo of those patterns can make a wonderful image. Look for those shadows and how they play across the ground or on the side of a building. Then take your photograph up close, and showing just those shadows.

Light Can Hurt Your Photos (What to Avoid)

This chapter has already given you several ideas about problem light and shadows. But if you do not pay attention to some distinct light

challenges, you will not get the best photos that you and your camera are capable of. There are definitely some lighting conditions to avoid.

Beware of Harsh Midday Sun

That bright midday sun can be a real problem for photographers. It is a time of day when everyone is out, but the light is often filled with too much contrast between shadows and highlights. The shadows are also often in the wrong places for the subject to look its best. Sometimes you just cannot get a good photo at this time.

Watch Out for Hot Spots

The camera cannot handle the extremes of light that are common both indoors and out. Yet people can see beyond those extremes and see detail that a camera cannot. Do not get fooled by bright spots of light that end up as hot spots in your photograph. Look for them, and if you need to, check your playback in the LCD to look for them again.

Avoid Shadows That Cover Good Parts

A severe problem with light is a hardedged shadow cutting across your subject in an inappropriate manner. That shadow can be very disruptive and distracting. In harsh light, these shadows can make it hard to actually see your subject clearly.

Avoid Light That Is Away From the Star

If you ever go to a stage show, you immediately see how the actors get the good light. The actors are the stars of the show — not the stagehands, not the orchestra, not the audience — and so the light favors them. This idea fits photography just as well. Watch your subject so that it gets the important light.

Low Front Light Can Be Beautiful

Front light is light that is hitting the front of your subject, as seen from your camera position. It is definitely a light with many qualities, both good and bad. It is the light that people used to say you always had to have:

light coming over your shoulder and hitting the subject. Today you hear a lot of photographers say that you should always avoid front light. You do not need to have this light or avoid it, but it can be useful to understand.

Front Light Can Be Boring

Front light is often boring because it has few shadows. The shadows fall away from the subject toward the background. Midday front light is generally not an attractive light because it is too high. That creates small, harsh shadows (such as under eyes or a hat brim) and flat light elsewhere.

Low Front Light Is Dramatic

When the light gets low, it is less harsh than midday light and has a rich quality to its highlights and shadows. It can become like a low spotlight at a theater and get quite dramatic when the foreground is in shadow and the background is dark.

Low Front Light Is Colorful

As the sun gets lower and approaches the horizon, it warms up and adds great color to a scene. This can be a very beautiful light, and you often see it used by Hollywood in films for a romantic look. It is an easy light to shoot in, although it can be hard on a subject's eyes.

Low Front Light for People

A low front light can be very attractive for people. This type of light gets into the shadows on their faces, making eyes bright and filling in wrinkles. You may find that your subject has trouble looking into the light. Have them look down as you get ready, and then up and into the camera just before you take the picture.

Make Textures Show Up with Sidelight

Sidelight is light that comes from the side of both you and your subject. It can be high or low, which modifies its effects, but the important thing about sidelight — its ability to highlight textures and dimensions — never

changes. Like all other light, sidelight is not arbitrarily good or bad — it all depends on what it is doing to the subject. It can be a harsh light that is very unforgiving to a subject, or it can be the perfect light to show off details.

Make Textures Come Alive

Texture shows up when light hits the high points and shadow fills in between them. That is exactly what sidelight does. It can only brighten the high points as it is not positioned to fill in the low areas. This effect can be quite dramatic with a sidelight that literally skims the surface of your subject.

Use 3/4 Sidelight for Form Plus Texture

When a subject has dimension and form, a pure sidelight might not be best for it. In this situation, you might look for a light that comes from the side, but between you and the subject, for what is called a 3/4 sidelight. This type of light makes forms look good and still brings out textures.

Use 90° Sidelight for Strong Texture

When that sidelight is at a 90° angle to the axis between you and your subject, texture can get really dramatic. However, you do need that textured surface to be fairly flat and without a lot of dimensional shape. As soon as the surface gains form, the 90° light literally makes it look like it is cut in half from the light and dark, and so that texture is not seen well.

Sidelight Can Obscure

Sidelight is a light filled with shadow potential — that is what makes the texture — but it is also light that creates shadows cutting across your subject. Be aware of that possibility, and look for these types of shadows so that you can avoid them. Hard-edged shadows are the worst in this light.

Separate with Backlight

A lot of photographers are afraid of backlight—light that comes from behind the subject and toward the camera. Years ago, amateurs always avoided it because the films, meters, and cameras of the day could not render it attractively. It is true that this type of light has its challenges,

but it is also a dramatic light that professionals use all the time. They also use it because they can create images that most amateurs never get, because the latter do not want to shoot into the light.

Backlight Separates Parts of Your Photo

Backlight is a separation light. This means that the light has a lot of light and creates a lot of shadow. The light hits the tops of subjects or other parts of your scene, and then contrasts with dark areas just behind them. This helps these picture elements to stand out and become separate from the rest of the image, giving depth to the photo.

Backlight Is Dramatic

Backlight is always a light of bright areas and dark areas, highlight and shadow. Because of that, it tends to be a dramatic light. This is another reason that professionals like it. You can use that drama by looking for where the bright and dark areas fall on and around your subject.

Exposure Can Be Tricky

Whenever you have bright and dark areas close together, exposure can be a challenge. In general, it is best to expose to be sure the bright areas have good detail and are not washed out. Check your LCD playback to be sure you have detail where it is important, and then change your exposure if you do not.

Watch Out for Flare

Backlight means that the light is heading right at you and the lens of your camera. That light can both create your photo and bounce around inside your lens, causing annoying flare. Use a lens shade when you can, to block extraneous light. You can also use your hand to shade your lens — just be careful it does not get in your photo!

Add Impact with Spotlight

You know what it means to be in the spotlight. It is a theatrical expression that says you are getting more attention. Often that is exactly what you want to do with your photographs — give your subject more attention. Many lights

can act like a spotlight and give that added attention to your subject by putting it in the light, while the rest of the scene is in darkness. Shadows can be as important as the light in order to set off your subject.

A Spotlight Is Like a Theatrical Light

The lights dim and a spot of light appears on an actor. You know immediately where to look and where your attention should be. Light can do the same for your photographs and create a spot of light that tells your viewer exactly where to look in your picture.

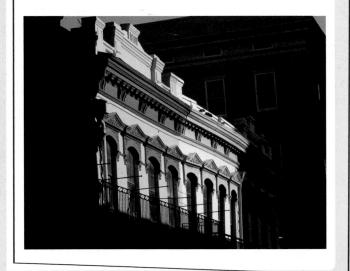

Spotlight Can Clearly Show Your Subject

In the theatrical example, you know that the spot-lit actor or action really stands out clearly on the stage. When you can find a spot of light on your subject, that same effect occurs and you ensure that the viewer of your image can clearly see the subject.

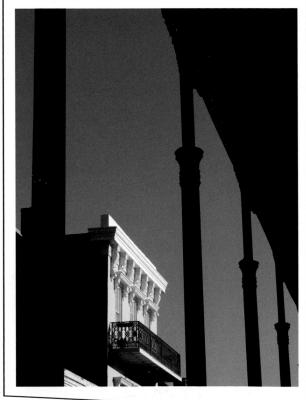

Spotlight Can Make a Scene More Interesting

Sometimes a scene that gains a spotlight just picks up interest from the drama that it provides. Many scenes look a little flat in average light. But when the sun changes its angle to the scene, spots of light appear that give life to the scene. Even very average-looking scenes can gain an excitement from this light.

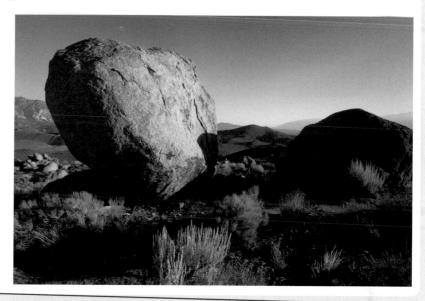

More Exposure Challenges

Spotlights on a scene mean contrast between the bright and dark areas. Anytime you have this contrast, you can have exposure problems. The most common problem to watch for is too much exposure that makes the spot-lit area look too bright, or even washes it out.

Turn On Your Flash When the Light Is Harsh

Nearly all digital cameras have a built-in flash. Many photographers do not know that they can use their flash at all times, including during the day. Keep in mind that your built-in flash is light that is always available and can help you

out when the light gets harsh and unattractive. It is easy to turn on the flash and just try it, even if it does not always help. Believe it or not, every photo in this section uses flash in some way.

Brighten a Subject on a Dull Day

Sometimes the light just will not cooperate. The day is dull, the sky is lifeless, and the colors just do not look lively. Try your flash to boost those colors. It mainly affects things closer to the camera, but that is often just what is needed to make the scene look good.

Flash Can Make a Dark Subject Bright

A problem in certain kinds of light is that the subject can get very dark. Photographing a subject against a bright background, such as a sky, can make the subject look very dark if the sky looks good. The flash can brighten the subject to a good level, while the camera still keeps the background from getting washed out.

Flash Can Change a Scene

Sometimes a background just does not look great. You can make it dark by using your camera's Manual exposure setting and underexposing the scene. If you are not sure how to do this, just try some settings and see what happens in the LCD. Then turn on the flash and use it normally to give a good light on your subject.

Try a Flash Off the Camera

Many digital SLRs have the capability to wirelessly work with a separate flash off camera. All digital SLRs can work with a flash that is attached with a flash cable designed for the system. This gives you a lot of possibilities to move the flash and change your light's direction, especially when shooting close up to a subject.

Time of Day Changes the Light

Light is not the same throughout the day, yet many photographers insist on photographing the same way throughout the day. That can result in unsatisfying photographs. Early and late light is low in the sky and changes scenes. Midday light is high and can be harsh and unappealing if photographed the same way as early or late light. By becoming aware of how light changes during the day, you can work with light rather than fighting its effects.

Early Light Is Great Landscape Light

You often hear about nature photographers getting up early for the light. Low, gently colored light of dawn is usually a crisp light that really brings out the features in a landscape. That low light can look great on landscape forms and textures. The good light is usually gone by mid-morning.

Use Midday Light for Close-Ups

Midday light can be harsh with ugly shadows because it comes from above. It can be very unattractive for large scenes such as landscapes, and unappealing for people because of the shadows. However, it can work for close-ups because you can easily move around these subjects to find the best light on them.

Late Light Is Warm and Beautiful

As the sun heads down toward the horizon for sunset, it gives a warm light that is usually much gentler than sunrise light. This can be a beautiful light for many subjects, and it is also a light that works well from all directions — front, side, and back — although how well it works depends on the subject.

Keep Shooting after the Sun Has Set

For many photographers, it is time to pack up and go home when the sun has set. However, the time after sunset can give excellent results with digital cameras. You may have to wait a few minutes, but there is often a wonderful warm, soft light that comes from the afterglow of the sunset.

Try Out Night Light

Night photography had a lot of problems when film was the only option. Often you had no idea of what you would get from photographing a scene until you had the film processed. Digital makes night photography so much easier to do, and so you can quickly master it. Night offers so many opportunities for some really different pictures that everyone else does not have. You will even find scenes that magically change from boring to exciting as the night lights come on.

Digital Cameras Make Night a Great Time to Shoot

Night photography had a lot of problems with film. For example, it was really difficult to get the right exposure or color. Now you can just take a picture and look at it with your LCD to be sure you got an interesting photo. Digital cameras also really seem to dig interesting light out of even the darkest night scenes.

15

Change Your ISO As Needed

ISO settings on a digital camera can be adjusted for more or less sensitivity, which could never have been done with film. Use a high setting when you want to try shooting handheld, or a low setting when you use a tripod. Even moderately high settings can look better than high-ISO film looked.

Support Your Camera for Long Exposures

Night often means long exposures. That can result in blurry photos unless you support the camera. A tripod is best, but avoid flimsy tripods that are too light, as they vibrate during exposure. You can also use an easily carried beanbag, which you can prop against a solid surface.

Look for Moving Lights

A really cool effect can come from night shots when you combine many-second exposures with a scene that has moving lights, such as a street scene. Those lights blur and create lines of light going through your photograph. You cannot fully predict what they will look like, so experiment with different times of exposure.

Understanding Exposure and White Balance

Exposure is a basic part of photography. It is based on how long the light hits the sensor and how much light comes through the lens. A good exposure makes colors and tones look right in the photograph.

Today's cameras have built-in exposure systems that do a fantastic job. But tough situations can challenge that

system. Your camera's computer cannot always tell what is important and what is not when the light on the subject is not average. In this chapter, you will learn about exposure so that you can make adjustments that will help you consistently get better photos.

What Your Camera Meter Does 62
The Problem of Underexposure64
The Problem of Overexposure
Correct Exposure Problems
What Is White Balance?70
When to Use Auto White Balance
When to Use Definite White Balance Settings
Using White Balance Settings Creatively

What Your Camera Meter Does

A key to understanding how to get good exposure is to understand how your camera meter actually works. Most people think it is designed to give a good exposure. In fact, it cannot do that because a meter can only tell you how much light it thinks is in your scene.

A camera meter does not know what kind of light is there — it cannot know the difference between bright light and a white subject, for example. Its measurements are based on the idea that the scene is average in brightness.

The Meter Only Measures Brightness

Most digital cameras have many tiny meters evaluating a scene. Each one can only measure the brightness of the light coming into the camera from that scene. A meter cannot tell the difference among such scenes as a dark subject in bright light, a bright subject in dim light, and an average scene in average light, and so it can misjudge the amount of light that is available for a photograph.

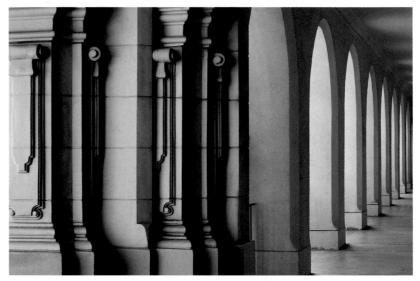

Exposure Is Based on Interpretations

The camera's meter does not give you an exposure. Your camera takes multiple exposure readings from the scene and uses its computing power to interpret the readings in order to give a good exposure. Cameras use information like focus distance to give emphasis in that interpretation to the subject, which will be in focus.

Dark Scenes Are Often Too Bright

When a scene is filled with dark colors and tones, the meter has no way of telling that this is not from too little light. As a result, metering systems give too much exposure to compensate for dim light. The result is that the scene is often overexposed, which can result in bright areas losing detail because they are too bright.

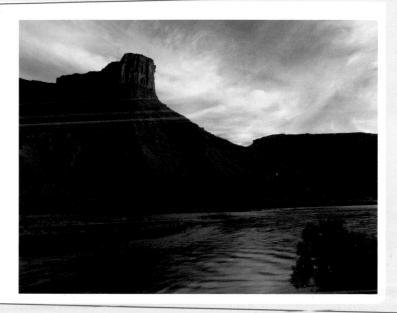

Bright Scenes Are Often Too Dark

Conversely, when a scene is filled with light colors and tones, the meter has no way of telling that this is not from too much light. As a result, metering systems compensate for this bright light by giving less exposure. The result is that the scene is often underexposed, which can result in highlights looking muddy and dark areas losing detail.

The Problem of Underexposure

Underexposure causes problems for photographers. You may hear some photographers say that they can fix underexposure in Photoshop, and so they do not worry about it. That is not a good way to approach photography. Underexposure creates some serious quality issues, including

increased noise and weaker color. Prints from underexposed image files look muddy and dark. Underexposure uses your camera's sensor poorly because it is not "seeing" the full range of tones that a sensor can capture.

Color Is Lost

Bright colors get dark, but dark colors get very dark. The camera cannot see dark colors the way people do, and the *chroma*, or color quality, of a color can drop considerably. The result is that as a dark image is brightened, it ends up with much weaker color.

Watch Out for Bright Lights

Bright lights, such as the sun or a strong artificial light, usually cause the camera's metering system to underexpose a scene. The meter is just doing its job, telling the system it found something bright, but then the system overcompensates and makes everything too dark.

Dark Tones Become Hard to Separate

When a scene is underexposed, the dark tones get darker. This means that they all cram together at the bottom of the tonal range, into the darkest tones. They can even disappear into black. Once those tones are crushed into the limited area of darkest tones and black, they can be difficult to impossible to separate again into different tones.

Noise Is Increased

Dark areas are where noise resides. Noise looks like someone sprinkled sand on your photo, adding what looks like film grain. So if an image is underexposed, much of its detail and color ends up in that noise. When the photo is processed to brighten it and make the detail and color more visible, the noise comes right along, and can become quite annoying.

The Problem of Overexposure

Overexposure is usually a problem in small areas. You really have to do something wrong to get a whole image overexposed, and so this problem is easily corrected. What usually happens with overexposure is that the camera

overreacts to something dark throughout the image area, and then makes it too light, which makes bright things way too light. Beware of overexposure whenever there are small bright areas in a large photo with lots of dark areas.

Highlights Are Lost

When too much light hits your camera's sensor, the brightest areas of a scene overpower its capabilities to capture detail. As a result, detail disappears. There is no fixing it in Photoshop, because there is nothing there to fix except for blank, white space. Blown-out highlights can be very unattractive.

Colors Get Washed Out

As exposure increases, colors get brighter and brighter. With overexposure, they become so bright that their inherent color starts to fade. Colors wash out, becoming pale renditions of the real-world colors. You can darken pale colors somewhat in the computer, but that takes time and you still miss the original colors.

Shadows Are Too Bright

As exposure increases, shadows brighten, revealing detail within them. That is good if your photo is entirely in the shadows. But if your photo includes a larger scene with bright light, the shadows start to look unnatural and a lot less like shadows. Shadows need to be dark enough that they look like shadows in a photograph.

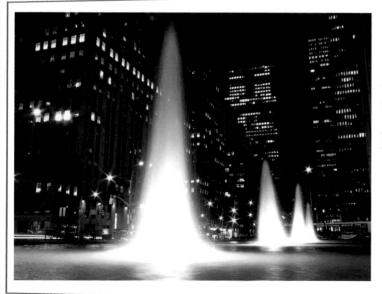

Overexposure Is Common with Dark Scenes

Dark scenes make your metering system give more exposure. This can be a real problem when the result is blown-out highlights, and shadows that are too bright. This type of image looks harsh and unappealing. Dark scenes need to be exposed in a way that keeps them dark.

Correct Exposure Problems

Now you have an idea of how metering systems work and what exposure is all about. While your camera works to give you good exposures, sometimes it misses. You can see that the wrong exposure can cause some distinct problems for a photograph, from added, annoying noise to

washed-out, detail-less highlights. Your camera does have the tools to correct these problems. Some cameras have more than one, but all cameras have features that help you get consistent, better exposures.

Use Your LCD

Your camera's LCD is a place to start when you check exposure. It is not calibrated the way a computer monitor can be calibrated, but you can still use it. Look at small areas, especially if they are bright. Enlarge the photo so that you can see if the bright areas hold important details or are washed out and empty white.

Exposure Compensation Can Help

Nearly all cameras have exposure compensation. This allows you to make the camera give more or less exposure than the metering system chooses. Add exposure by moving exposure compensation to the plus side, and reduce exposure by moving it to the minus side.

Lock Exposure to Deal with Problems

Most cameras let you lock exposure to limit the metering system's changes. Usually, you just point the camera at something brighter to decrease the exposure, or at something darker to increase the exposure, and then press the shutter halfway to lock exposure. You then point the camera back to your subject and the chosen composition.

Try AEB

Advanced digital cameras and digital SLRs often include auto exposure bracketing, or AEB. This allows you to set the camera to take several photos in a row, each image with a different exposure, so that you can find the best exposure later. Set the amount of AEB and choose the continuous-shooting setting.

What Is White Balance?

White balance is a terrific new tool for digital photographers that gives your photos more accurate and pleasing colors by matching the way the camera captures them to the color of the light. White balance affects how an image

is recorded so that color casts are kept out of your image. If an object is gray, it will look gray in your photo. If it has a color, the color will look accurate and natural.

White Balance Keeps Neutral Tones Neutral

White balance affects more than white. It makes all neutral colors, from white to gray to black, remain neutral. People's eye-brain connection makes neutrals neutral automatically, but a sensor does not do that. The camera has to be told how light is affecting neutral tones.

You No Longer Need Special Color Filters

With film, you would need specially colored filters matched to a film type to make neutral tones neutral. Without these filters, fluorescent lights made scenes look green, and incandescent lights could give an orange cast to subjects. These filters could be used when the photo was shot or when a negative was printed.

Color Casts Are Removed

Color casts used to be a common problem with color film. For example, the whole image would look like it had an orange or green haze to it. Digital cameras let you adjust them so that these color casts disappear and a scene looks closer to the way you actually see it.

White Balance Comes from Using a White Card

You might wonder why this control is called white balance. Years ago, a video camera had to be told what neutral was so that it could balance colors to the light. Videographers would point the camera at a white card and set a control that would tell the camera to make the white a true white.

When to Use Auto White Balance

Your camera comes with the ability to automatically make adjustments to get rid of color casts, and to make neutrals such as white, gray, and black truly neutral. This is called auto white balance, and is often shown as AWB on your camera. This is the default setting of your

camera and works well in many situations, but sometimes it does not work as well as you would like. You need to know what it can and cannot do if you want the best from your colors.

AWB Makes White Balance Easy

Auto white balance is simple. You set nothing, and so it makes the control very easy to use. The camera analyzes a scene and tries to figure out what the light is doing to colors. Then it creates a setting for the camera that attempts to make colors look accurate, and to show neutrals without color casts.

AWB Can Cause Problems with Sunrise and Sunset

Your camera's white balance system has no way of knowing that a sunrise or sunset is supposed to have a warm color cast to it. It just sees that all the neutral tones have color in them, and so it removes some of that color and takes some of the life out of the scene.

AWB Works in Most Light

A good thing about AWB is that it works in most light. You can go from inside with fluorescent lights to outside sunlight, and expect to get reasonable colors with your camera. AWB is really helpful when you are changing from one location to another or the light is hard to figure out.

AWB Can Be Inconsistent

A problem with AWB is that it can give inconsistent results. For example, when you zoom from wide to telephoto, the camera may see different colors in the background and think that the light has changed. It then adjusts white balance when it should keep it constant.

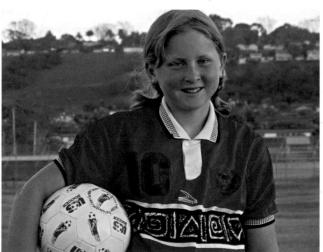

When to Use Definite White Balance Settings

Your camera comes with a group of preset, defined white balance settings. Even the most inexpensive cameras typically have these controls that take the camera off of AWB, but most photographers do not know that they exist. Sometimes they are in a menu,

sometimes they are accessed directly by a WB button. These settings define the response of the camera to a specific color of light, although they can be used in other conditions for creative effect as well. They can really help you get better color.

Defined Settings Lock the Camera's Response

When you set a specific white balance in your camera, you lock it down to that specific interpretation of the light. It does not change, even if you point the camera elsewhere, zoom the lens, or change your location. This restricts the camera's response to how it interprets a scene.

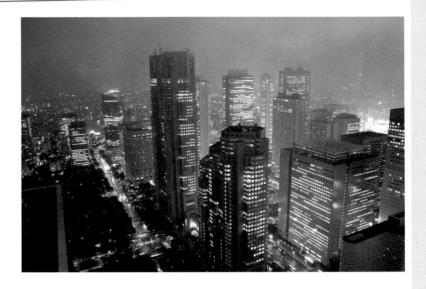

Defined Settings Are Consistent

With a specific white balance setting, you can zoom your lens in or out and be sure the color of your subject's skin will not change. You can also move around a location and know that a change in the color of the background will not throw your colors off.

Match Settings to Conditions

The basic way to choose a defined or preset white balance setting is to match the setting to the conditions. Choose Sunlight for sunny days, Cloudy for cloudy days, Shade for shade, and Tungsten for indoor light.

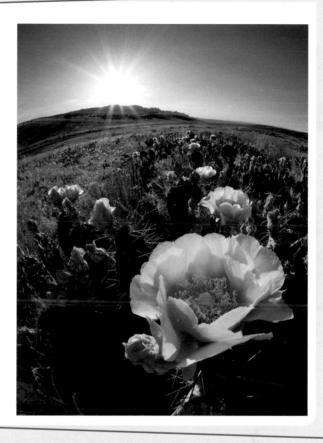

Warm Up Your Photos with White Balance Settings

You may like photos that are a little warmer in tone than the camera gives you. You can change your white balance to always warm up scenes. For example, try Cloudy for a daylight scene or Shade for a cloudy day, and see if the colors look better to you.

Using White Balance Settings Creatively

White balance settings do not always have to exactly match the conditions. You can use white balance settings for creative control that goes beyond simply making colors look more natural. You can choose presets that seem to be completely alien to conditions, just for their

effects. There is no rule that you have to use the Daylight setting with daylight — no white balance police will arrest you if you use something different. And there is no quality effect from using something different.

Experiment with White Balance

You start with the Sunlight setting for sunny conditions, but there is no rule that says you cannot use completely different settings for your shot. Just to see what is possible, take a series of pictures of the same scene, but with the white balance set to a different setting for each shot.

Use the Cloudy Setting for Sunset

Sunset photos are supposed to have rich, warm colors. This is an expectation that comes from how film used to capture sunsets. Digital cameras give much weaker interpretations of sunset unless you choose a specific white balance setting. The Cloudy setting always gives richer sunsets than AWB.

Try the Daylight Settings at Night

It would seem logical to use a Tungsten or Indoor setting for the lights at night. Yet that often gives such a neutral-looking image that the colors that you would usually expect disappear. You can get them back by using a Sunlight setting.

Create Blue Effects with Tungsten

Tungsten settings are designed for shooting with artificial light, not for daylight. This means that you can get unusual, often striking colors by using Tungsten for daylight. It turns daytime scenes blue. With a little underexposure, you can even make them look like night.

Choosing Shutter Speed and F-Stop

Two basic controls change how much light hits the sensor in your camera: shutter speed and f-stop. Shutter speed affects how long light is allowed into the camera. Shutter speed is often displayed as just the bottom number — for example, 1/125 second appears as 125.

F-stop determines how much light is allowed through the lens. It is controlled by changing the aperture, or the

size of the opening in the lens. A larger opening, such as f/2.8, uses most of the maximum diameter of the inside of the lens. A smaller opening, such as f/11, uses an aperture that is less than the diameter of the inside of the lens.

Control Exposure with Shutter Speed and	F-Stop 80	
Stop Action with Fast Shutter Speeds	82	
Blur Action with Slow Shutter Speeds	84	
Increase Depth-of-Field with Small F-Stops	s 86	
Create Shallow Depth-of-Field with Large F-Stops 88		
ISO Settings Affect Exposure Choices	90	

Control Exposure with Shutter Speed and F-Stop

Shutter speed and f-stop work together to create an exposure for your subject. As a result, you have many options because the combinations of shutter speed and f-stop add up to a very large number of choices. You can potentially use each shutter speed with every

f-stop, and vice versa, to match a huge range of brightness conditions. You do not have to choose every setting yourself because the camera will help you with specific choices, depending on the exposure mode you choose.

Shutter Speed and F-Stop Have a Direct Relationship

As shutter speed is changed, a corresponding amount of f-stop must change in order to keep the exposure the same. The camera typically does this for you as you change shutter speed or f-stop with autoexposure. However, with this knowledge in mind, you can affect exposure by using different shutter speeds and f-stops.

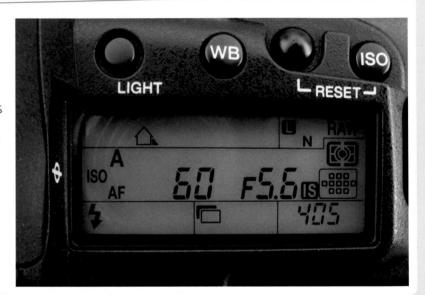

F-Stops Change in a Regular Way

The most common f-stops are f/2, f/2.8, f/4, f/5.6, f/8, f/11, f/16, and f/22. The biggest is f/2, which lets in the greatest amount of light. The smallest is f/22, which lets in the least amount of light. These are full f-stops, and each gives an exposure that allows twice the light through the lens when you go from one f-stop to the next, such as from f/22 to f/16 to f/11, all the way to f/2. Each halves the amount of light when going the other way.

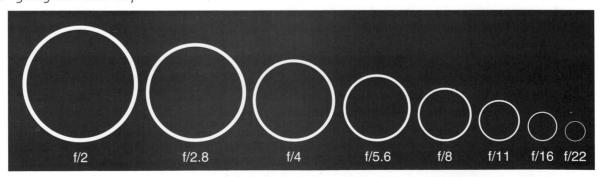

Shutter Speeds Change Intuitively

Shutter speeds represent the amount of time that light hits the sensor, such as 1/125, which may also be displayed as 125. A shutter speed of 1/125 is half the speed of 1/60, which means that it lets in half the light, and twice that of 1/250, which means it lets in twice the amount of light. Such a change represents a full step or full stop change. The stop refers to a full f-stop change in exposure.

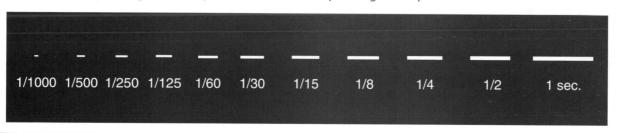

You Can Choose Either Shutter Speed or F-Stop with Autoexposure

When you choose P or program autoexposure, the camera chooses both shutter speed and f-stop. With A, Av, or aperture-priority autoexposure, you select an f-stop and the camera chooses an appropriate shutter speed. With S, Tv, or shutter speed-priority autoexposure, you select the shutter speed and the camera chooses the right aperture.

Stop Action with Fast Shutter Speeds

Fast shutter speeds stop action. If action is an important part of your photography, then shutter speed must be your main consideration. Aperture, or f-stop, is usually far less important. If action is supposed to look sharp — and it usually is — then you need a shutter speed fast

enough to stop that action for the photograph. Exactly what shutter speed to use varies depending on the situation. You can choose that speed based on what you discover about the speed of the action. You can try different speeds until the action appears sharp in your LCD.

Movement Is About Time

Anything that moves is changing over time. A slow shutter speed shows how something moves during the time the shutter is open, and so you get a blur. A fast shutter speed captures a moment in time of that movement, a short enough moment to render the action sharp.

18 SFS 100

Speed of Movement Affects Shutter Speed Choice

Any action has a speed. A person walking has less speed, and therefore less movement through time, than a runner or a bike rider. Shutter speeds must get faster in order to stop action as it increases in speed. You might stop someone walking at 1/125 second, but a sprinter might require 1/500 second.

Angle of Movement Affects Shutter Speed Choice

Your angle to the subject also affects the shutter speed you need. If a moving subject heads toward you, you see less movement over time, and so you can use a slower shutter speed. As the moving subject changes direction and goes at 90 degrees to your view, the subject changes very rapidly going across the scene, and so you must use a faster shutter speed.

Timing of the Shutter Affects Movement

As shutter speeds get faster, such as 1/125 or 1/500 second, time is sliced into shorter and shorter moments. Movement is frozen because it is captured in such a short part of its time of action. There are many such moments in any movement, and timing of your shutter release can change the photograph.

Blur Action with Slow Shutter Speeds

Shutter speed is not simply about stopping action. A speed can be too slow for a particular action, causing the movement to be blurred. This is obviously a problem if you want to stop the action of an athlete but only get a blurry image. However, blurs can be used creatively

and can show more of the world than we can even see. If you want to experiment with blurs, then be sure to choose a shutter speed that really blurs the subject. Slight blurs look like a poorly photographed subject or like a mistake.

The World Is Not Timed to a Shutter Speed

The camera artificially stops action so that you can get a photograph. Movement can be photographed in other ways than simply stopped action, however. When you photograph movement over time, you get a blur, but you also see what movement looks like from a different timeframe.

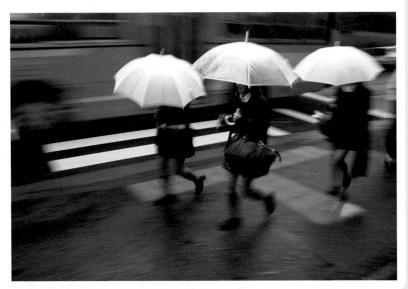

CAPUR

Slow Shutter Speeds Create Blur

Slower shutter speeds mean that your shutter is open while movement and action occur. That creates blur. How slow a shutter speed will cause blur depends on the movement. A hummingbird's wings can be blurred at 1/10,000 second, but a snail is not blurred at 1/60 second.

Water Looks Great with Slow Speeds

Water is a classic subject for slow shutter speeds. This allows you to get those beautiful, smooth water shots that actually show the flow patterns of the water. Try shutter speeds of 1/2 to 1 second at first, and then check the results in your LCD. You need a tripod or other camera support for slow speeds.

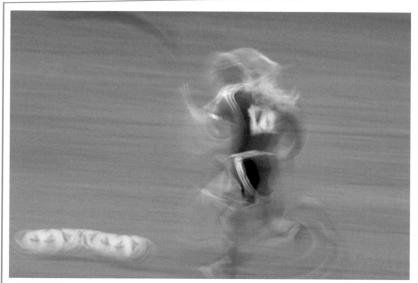

Blurs Can Be Creative

When slow shutter speeds are used on other subjects, the results can be unpredictable, but also quite attention getting. For example, try sports action at 1/8 or 1/15 second. Follow the subject as they move, and then release the shutter as you continue to pan with the subject.

Increase Depth-of-Field with Small F-Stops

Many photographers seek to gain great sharpness throughout their scene. The choice of f-stop has a very big effect on sharpness in depth in a photograph, or depth-of-field. As you choose small openings or f-stops, depth-of-field increases. There is a trade-off, however: As the

f-stop gets smaller, less light comes through the lens. This means that shutter speeds get slower, increasing the chance of blur. You often need camera support, such as a tripod, for maximum sharpness when you also want maximum depth-of-field.

Small F-Stops Have Big Numbers

F-stops are a little confusing because as they get smaller, the numbers get bigger. This is because the numbers actually represent a fraction, so while 8 is a larger number than 4, 1/8 is smaller than 1/4. This is exactly what happens with f-stops; f/8 is a smaller opening or aperture than f/4.

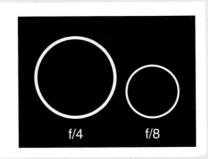

Depth-of-Field Is Sharpness in Depth

Depth-of-field represents the amount of sharpness in a photograph from near to far, or the sharpness in depth. A photograph that starts sharp with nearby objects and stays sharp into the distance has a lot of depth of field. An image with a very narrow band of focus is said to have shallow depth-of-field.

Small F-Stops Give More Depth-of-Field

As f-stops get smaller in size, depthof-field increases. A smaller f-stop is represented by a larger number, such as f/16. Use those numbers to your advantage by remembering that larger numbers give more depth-offield, regardless of the math behind them. Landscapes are good subjects for a lot of depth-of-field.

Watch Your Shutter Speed

You can set a small f-stop with aperturepriority autoexposure, or you can watch to see what the camera is doing with other autoexposure modes. You also need to watch your shutter speed. Slow shutter speeds are often needed with small apertures, which can result in blurred photos.

Create Shallow Depth-of-Field with Large F-Stops

While deep depth-of-field can be nice for a landscape or a travel scene in some distant city, it can be a problem with some photos. Your subject can blend into a background at times if both are equally sharp. For example, you may not necessarily want the background to be sharp

and competing with your nice portrait of your son or daughter. Or, you may want to be sure your photograph of a flower actually makes the flower stand out for a viewer — it will not if the background is too sharp.

Shallow Depth-of-Field Limits Area of Sharpness

Shallow depth-of-field limits sharpness in depth. It does not change sharpness from side-to-side, but it does keep sharpness focused on a specific area of the photograph. This also helps the viewer focus on what is important in your image.

Wide Apertures Reduce Sharpness in Depth

A wide or large aperture in the lens reduces the amount of sharpness in depth that is possible in a photo. These are the f-stops with the lower numbers, and so you can also remember this by thinking that a low f-stop number creates a low or restricted depth-of-field. The lower the number, the larger the aperture, and the less the sharpness in depth.

Telephotos Enhance the Effect

Telephoto lenses, or the telephoto-magnified portion of your zoom, give less depth-of-field at any given aperture. Conversely, wide-angles give more depth of field. Any time you want to decrease depth-of-field, use your telephoto lens settings and back up to get the subject into the image area.

Shallow Depth-of-Field Makes Your Subject Stand Out

So why use shallow depth-of-field? Because this always makes your subject stand out. The contrast from sharp to fuzzy is always a helpful way of separating your subject from the background. Shallow depth-of-field is also what you see when focusing through a digital SLR.

ISO Settings Affect Exposure Choices

Light never remains constant. It changes in so many ways, but especially in brightness. Your camera gives you some control in how the camera responds to that brightness, in the form of ISO settings. These settings change the sensitivity of a camera to light so that the sensor records an image appropriately. Film has ISO numbers

that relate to each film's sensitivity. In a similar way, ISO settings reflect how sensitive the camera is to light. The numbers change sensitivity in direct relation to their mathematical change; for example, going from 100 to 200 doubles the sensitivity of the camera.

ISO Settings Boost the Sensitivity of Your Camera

ISO settings on a digital camera are not exactly the same as ISOs of film. Film ISOs were locked into a specific film. You can change digital ISO settings at any time. Increasing ISO settings amplifies the sensor's sensitivity to light so that you can shoot more easily in low light levels.

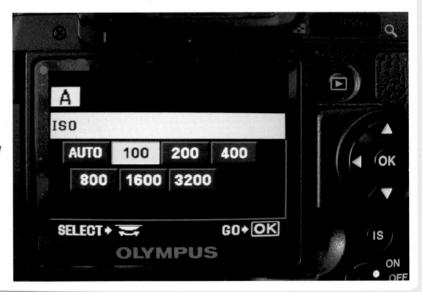

Low Numbers Give Highest Quality

Low ISO settings are based on the native sensitivity of the sensor, and they give optimum color and tonality. In addition, the lowest noise levels come from low ISO settings. The downside is that you often need slower shutter speeds, which can cause a lack of sharpness either from camera or subject movement.

High Numbers Allow Faster Shutter Speeds

Using high ISO settings is like turning up the dial on your radio to bring in a weaker station. Higher settings "turn up the dial" on the sensitivity of your sensor and allow you to shoot in lower light levels. The effect of specific high ISO settings varies from camera to camera, but they may result in weaker color and increased noise.

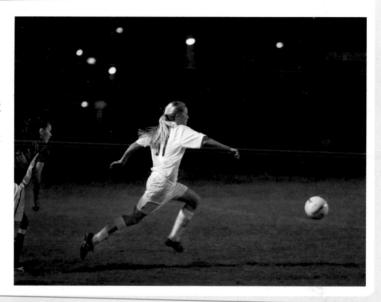

A Caution about Noise

Noise is a pattern of random bits of tiny detail that appear across your image. It looks like sand and is the digital equivalent to film grain. It can be a problem if it is distracting from your subject, but it can also be necessary if you are to get the shot. Noise always increases with high ISO settings and underexposure.

Chapter 6

Getting Maximum Sharpness

For most photographs, sharpness is a key element that helps make the image good or bad, useable or not. A lot of photographers try to "buy" sharpness by purchasing expensive lenses or expensive cameras, yet they are disappointed when their results do not match their expectations.

Sharpness might be considered a part of the photographer's craft. With practice, any craftsperson will get better in that field. If you try the ideas in this chapter, and then practice a bit with them, you will get sharper photos than someone else who does not pay attention to these ideas, regardless of the price of their lens and camera.

Minimize Camera Movement
Focus on the Most Important Part of the Subject 96
Choose F-Stop or Shutter Speed for Appropriate Sharpness
Get Maximum Sharpness with a Tripod
Get Sharpness with Other Camera Supports 102

Minimize Camera Movement

Camera movement during the exposure is probably the worst culprit for blurry photos. Small, lightweight digital cameras are easy to casually hold and shoot, yet a casual approach usually leads to less-than-satisfactory photos. For example, those little cameras can move very

easily from a hard push of the shutter button. In fact, all cameras and lenses can have their photos degraded from camera movement or shake during exposure. Holding a camera properly to minimize camera movement is not hard to do; unlearning bad habits may be harder.

A Handheld Camera Moves

Obviously, a handheld camera moves. It has to because you and your hands move. However, many photographers do not consider that possibility when shooting. They take it for granted that somehow the camera will take a sharp photo, and if it does not, it is because the camera is cheap.

Com

How to Hold a Digital Camera

You learned a little about handholding a camera in Chapter 1. This is so important that it is worth revisiting here. So often, you see folks holding a little digital camera, with one hand waving in the air. This guarantees photos that are less sharp. Hold the camera with two hands and bring your elbows into the sides of your body for the most stable position.

How to Hold a Digital SLR

A digital SLR is held similarly to a regular digital camera, except for the placement of the left hand. Turn that hand palm up, and place the camera down onto the palm. Then grip the lens naturally. This is a much more stable position than if the left hand is palm down.

Press the Shutter

How you release the shutter does make a difference. You want to steadily press the shutter down until it goes off. As noted in Chapter 1, never jab the shutter or quickly lift your finger. Either movement can jar the camera and cause unneeded camera shake during exposure.

Focus on the Most Important Part of the Subject

Autofocus, or AF as it is often called, is a great feature on all digital cameras. AF really does help to ensure that your photo is properly focused most of the time. This can be a challenge, however, when you are photographing up close. Then, the camera's AF system may focus on the wrong part of the subject because there are so many places to focus on, all at slightly different distances. Whenever you have objects at varied distances within your photograph, you have the possibility of the camera focusing on the wrong object.

Focus Is Narrow When You Are Close

When you get close — and this is not just for closeups — the area of sharp focus gets narrower. The actual point of focus becomes more obvious. This means that you must become more aware of where the camera is focusing and be sure that the important part of your subject is in focus.

The Camera Does Not Know What Is Important

The camera and its autofocus have no idea of what is or is not important in a photo. It is simply finding something that it "knows" can be sharp. You have to tell the camera what is supposed to be sharp, and so you need to watch the focus points and notice which ones light up to tell you what is sharp.

The Eyes of a Person Are Critical for Sharpness

In any portrait, formal or informal, the eyes of the person are a key part of that image. They tell a lot about the subject, which is why they must be sharp. If the camera focuses behind them and makes ears and hair sharp, then your photo is much less effective than it could be.

For Closeups, Check Where the Camera Focuses

With closeups, there are many spots that a camera can focus on, and they are all very close together in distance. However, what can be sharp is limited because of the distance. You may have to press the shutter to lock focus, as described in Chapter 1, in order to keep focus on the important parts of the photo.

Choose F-Stop or Shutter Speed for Appropriate Sharpness

As you learned in Chapter 5, f-stop and shutter speed control exposure. How you choose an f-stop or shutter speed will change the sharpness of your photo, with f-stop affecting depth-of-field and shutter speed either stopping motion or allowing blurs. This is an important concept to understand when you are choosing

either f-stop or shutter speed as your primary control. This section takes a look at both settings from a different perspective than in Chapter 5 — the perspective of sharpness rather than the controls — so that you can better choose what you need.

Foreground and Background Need Depth-of-Field

A great technique for getting a better landscape photo is to find a foreground that relates to a bigger scene in the background. These images often look their best when both areas appear sharp. You can get deeper sharpness in such images by using the smallest f-stops and a wide-angle focal length.

Fast Action Needs Fast Shutter Speeds

When the action is fast, you must choose a fast shutter speed. Your camera typically has speeds of 1/1000 second and faster. Use them when you can if the action is fast. Let the camera choose a wide aperture if needed, and use a higher ISO setting if you cannot get the speed you want.

Contrast of Sharpness Makes Sharp Areas Look Sharper

When you shoot with a telephoto lens and a wide f-stop, you limit your sharpness to a restricted depth in the photo. This allows you to contrast out-of-focus areas next to the sharp areas. These planes of contrasting sharpness can make your sharp area look even sharper.

Pan Your Camera with Slow Shutter Speeds

With slow shutter speeds, you get blur with a lot of action. Try panning or following the movement with your camera, and then shooting during that movement. This often keeps the subject sharp, or at least less blurred, while the background blurs into an interesting, muted pattern.

Get Maximum Sharpness with a Tripod

A good tripod is probably the best investment you can make for sharpness. You will not use it all the time, but it is invaluable when shooting at slower shutter speeds. Many photographers are surprised at how sharp their lenses really are when they see the results from shooting on a

tripod. Even at moderate shutter speeds, such as 1/60 or 1/125 second, most people cannot match the results from a tripod without using faster shutter speeds. The blur might not be noticeable, but the sharpness of details is affected.

Get a Sturdy Tripod

Too many photographers spend a lot of money on camera gear, and then skimp when it comes to buying a tripod. A light, flimsy tripod can be worse than no tripod. Set up a tripod, lock it down, and lean on it. A sturdy, appropriately stiff tripod does not feel wobbly or like it will collapse.

Carbon-Fiber Tripods Are a Good Investment

There is no question that carbon-fiber tripods are expensive. But their light weight means that you are more likely to take one with you and use it as needed. With reasonable care, they last a long time, and their cost is like an investment in sharpness that will pay off over time.

Ballheads Are Easy to Adjust

The ballhead uses a ball-and-socket mechanism under the camera mount to allow you to adjust the camera angle to the subject. A single knob locks and unlocks the head to move the camera. That single knob makes adjustment quick and easy, but hold the camera firmly as you do, or your camera may drop suddenly to one side or another.

Pan-and-Tilt Heads Offer Tight Control

A pan-and-tilt head is another common top for a tripod. It uses several knobs or levers to adjust the camera position. The multiple controls make it a little slower to use, but some photographers prefer the control it gives over each movement of the camera.

Get Sharpness with Other Camera Supports

Tripods are not the only option for getting added sharpness when shooting at slower shutter speeds. Traveling with a tripod can be difficult if you must pack really light. In addition, tripods can be hard to take to some places, such as when you are photographing along a historic street with a lot of tourists who might trip over them. Some places even prohibit them. Tripods can also be awkward to carry and move around in some settings, such as at sports events. Luckily, there are alternatives.

Beanbags Make Very Portable Supports

Beanbags are very pliable bags that let you prop a camera against a solid surface. Some actually have beans inside, although most have plastic pellets. The bag molds against the camera to help you hold it stable against a post, chair, bookcase, parking meter, or any other convenient, non-moving object.

Monopods Are Great for Sports Action

A monopod is like one leg of a tripod with a head on top. These are great for shooting sports, as the monopod can carry the weight of the camera and lens as you watch the action develop. They can be used in a lot of situations where you need a slower shutter speed but cannot use a tripod.

Gorillapods Wrap around Objects

A relatively new product, the Gorillapod looks like a miniature tripod with bendable legs. It comes in different sizes for different sizes of cameras. While it can support a smaller camera directly, most of the time a Gorillapod is used by wrapping its legs around a solid object, such as a post. The unit itself is very lightweight.

Table-Top Tripods Can Help with Small Cameras

Miniature, folding tripods can fit into a camera bag, and can be opened and used on a table or any other flat solid surface to keep your camera stable during exposure. The smallest ones can be kept with a pocket digital camera to let you shoot with slow shutter speeds anywhere.

Getting the Most from a Lens

The lens is a basic part of a camera. Without one, you cannot even take a picture. The lens controls what the sensor sees — such as how much of the scene, what is sharp or not sharp, and perspective. Compact and point-and-shoot digital cameras have built-in zoom lenses that change focal length. Digital SLRs allow you to change lenses for specific purposes.

The focal length you use with your zoom and the lens you choose for your digital SLR is a very personal preference. This chapter will give you some ideas on how to best work with a lens to meet your photo needs.

Get a Big View with a Wide Angle106
Get a Tight View with a Telephoto108
Zoom for Best Compositions
Choose Focal Lengths for Different Subjects 112
Closeups and Lenses
Focal Length and People Photographs
How to Buy New Lenses

Get a Big View with a Wide Angle

The wide-angle lens is often used specifically to get a wider angle of view on a subject. This is the most common use of such a lens. A wide-angle lens uses any focal length that lets you see a wider view than normal. It is always helpful when you cannot back up and a big

view is in front of you. Yet a wide-angle lens or zoom setting can do much more for you than simply get more of a scene. It can also be a useful and creative tool that changes how you photograph a subject.

Shoot the Big Scene

The world is a vast place, but it can also often limit you as to where you can photograph. A wide-angle lens can help you get more photographs of those big scenes. Remember that the wide angle gets "wider" top and bottom as well as side-to-side, so watch what goes into the top and bottom of your photo.

Go Wide Indoors

Digital cameras make indoor photography easy with white balance and ISO controls. A wide focal length lets you see more of the subject and its surroundings when inside. Rooms do not always give the photographer room to shoot easily, and so the wide-angle lens can really help to get everything or everyone into the shot.

Make Your Foreground Bolder

One thing a wide-angle lens always does is capture more foreground. Watch out for empty, boring foregrounds that a wide-angle lens can easily capture. Get in close to something special and create a photo with a very strong foreground-background relationship, as described in Chapter 2.

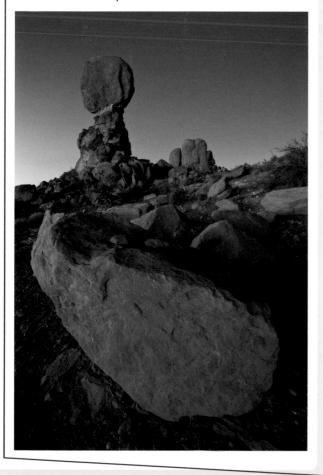

Wide Angle Allows Slower Shutter Speeds

Because a wide-angle lens covers a large area of a scene, it stands to reason that any slight movement of the camera during exposure will be less noticeable. You can often handhold a camera at much slower shutter speeds than expected if you shoot with the widest angle of your zoom.

Get a Tight View with a Telephoto

Telephoto lenses magnify a scene. Whether you get such a view from a zoom or a single-focal-length lens, a telephoto lets you pick out and isolate details in a scene. You can really focus on things that sometimes cannot even be seen well with the unaided eye. Stronger focal

lengths let you bring in subjects, such as wildlife, that are sitting some distance away so that they fill up your image area. A telephoto lens is an important tool for capturing segments of a wide world.

Telephotos Isolate Subjects

A telephoto lens allows you to eliminate unneeded details as you zoom in. But it also changes other details, such as perspective and depthof-field. This tends to make a subject stand out better against a background, isolating the subject out of the overall scene, and helping capture that subject more clearly.

Watch Your Shutter Speed

Telephotos see a narrow bit of the world. Any camera movement during exposure will definitely show up on that restricted angle. You need faster shutter speeds for telephoto lenses so that you can stop that movement. Most people cannot handhold any telephoto sharply at less than 1/125 to 1/250 second.

Use Telephoto for Details

As you zoom in, you start isolating and focusing on the fine points of a scene or subject. The telephoto lens lets you find interesting details about a subject. Search out color or texture that cannot be seen from a distant or wide view. Use your camera to extract information about your subject that other people miss.

Strong Telephotos Compress Distances

Ever see those photos of cars stacked on a freeway? They are almost always shot with a telephoto focal length. Telephotos bring in the background and make it look closer to your subject. You get the strongest effect by zooming in, and then backing up until the subject looks right.

Zoom for Best Compositions

The zoom lens on any digital camera can be a great compositional tool. Composition is always about what you include in your image and what you try to keep out. Your zoom allows you to do exactly that: zoom out to include more

details and more of a scene in the photo, and zoom in to eliminate details that you do not want. You can quickly focus a composition down to its essentials by using your zoom to change what appears in the photo.

Zoom Out to Include Environment

Sometimes the important thing about your subject is not simply the subject, but how it relates to its environment. Zooming out to a wider setting always allows you to include more of the environment. In addition, depth-of-field is increased, which helps that environment to be more readily seen.

Tighten Your Compositions

One problem many photographers have is that they do not get close enough to their subjects; the photograph has too much space around the really important part of the image. Try setting up your photo how you like it, and then just tap that zoom to magnify it a bit more. That will often make a stronger photo.

Zoom In to Focus on Your Subject

When the focus should really just be on your subject, zoom way in until that is exactly what you see and nothing else. You can make a subject look very dramatic if you get in close and use your zoom to its maximum magnification. If the subject is too pressed in by the edges of the composition, back up — do not simply zoom out wider.

Experiment with Your Zoom Range

If you want to learn the capabilities of your zoom better, here is a good exercise. Take a series of 30 photos, where each image uses a different extreme of focal length. Take the first photo at full wide angle, the next at full telephoto, the following shot at full wide again, and so forth. This can be a challenging and fun exercise.

Choose Focal Lengths for Different Subjects

As you think about focal length, you will quickly discover that certain focal lengths seem to fit specific subjects quite well, such as landscapes with wide angles and wildlife with telephotos. It is worth keeping that in mind. While you can certainly photograph any subject

with any focal length, you will find that some subjects are just easier to photograph with either telephoto or wide-angle lenses, but not both. It can be frustrating to try to force a subject into an image that the lens does not support.

Telephotos Are Great for People

Telephoto focal lengths can be very flattering for people. Try setting your zoom to its strongest point, and then back up until your subject looks good. With most standard zooms, this provides a very pleasing perspective for a person's face. It can also blur the background so that the subject stands out better.

Capture Wide Landscapes

Landscapes are often big, and you frequently have a limited location from which to photograph them. If you like photographing big spaces, a very wide-angle lens may be a necessity for you. You can get such lenses in certain compact digital cameras as well as digital SLRs.

Strong Telephotos Help with Wildlife

Wildlife does not generally sit still while you come up to photograph it. Even relatively tame animals are not comfortable with close approaches. You need a strong telephoto in order to photograph them. Common zoom ranges on compact cameras are typically too small to work for this subject.

Wide Angles for Travel

When you are traveling, you often need to show off a scene, and yet you are limited in where you can photograph from. A wide-angle lens can be great to get a quick shot of a nice location without spending a frustrating amount of time finding a place to shoot from. Wide-angle lenses also let you show the whole environment of a scene.

Closeups and Lenses

Closeup photography is a fun way to use your camera. All cameras today have the capability of focusing close, although some do better than others. Specialized lenses that are optimized for close work can be helpful, but you do not need them for starting to shoot closeups. Set your

camera on its closest focusing distance (or set to closeup focusing) and move in to find interesting subjects for your photos. If you want to go closer, your needs may be as simple as a special closeup lens.

Try the Close Focusing Setting

Even the most basic point-and-shoot camera usually has a closeup setting that allows very close focusing within inches of your subject. This setting is represented on most cameras with a flower icon. Give it a try with some subjects in your area. Most zooms for digital SLRs also have close-focusing settings that you can use to create closeup work with those lenses.

Add a Closeup Lens

An easy way to get closer shots with many lenses is to use a closeup accessory lens that screws into the front of your lens. You can even use these lenses with many compact digital cameras as well as digital SLRs. Look for achromatic closeup lenses for the best sharpness.

Extension Tubes Work with Digital SLRs

An extension tube is literally that, a tube that extends the distance from camera to lens. It allows all of your lenses to focus closer, although wide angles might not work. Extension tubes are very affordable accessories that open up closeup and macro photography for any digital SLR.

A Macro Lens Has Unique Features

You do not need a macro lens for closeup or macro work. However, such lenses do have advantages. They allow you to focus from a distance to up close without any other accessories or camera settings. They are also designed for maximum sharpness and detail when you are shooting very, very close to a subject.

Focal Length and People Photographs

Earlier in this chapter, you learned that telephoto focal lengths work well with people. This is true, and you are always safe photographing people with such focal lengths. However, good people photographers use all sorts of focal lengths to control the portrait even more. You

can get very unflattering photos if you use a focal length inappropriately, but all focal lengths work for people photos if you use the right approach. Do not simply use a lens to get wide or narrow; check the LCD and look at what it is really doing to your subject.

Wide Angles Show a Person's Setting

As you learned earlier in this chapter, wide-angle lenses let you add some environment around your subject. This can be a great way to tell a story about your subject by showing them in a personal space. Such images can bring texture and color to a portrait by keeping the subject in context with their surroundings.

Telephotos Let You Isolate Faces

When you zoom in and concentrate on just a person's face, you make your viewer really look at that person. Such a close view focuses in on the eyes, a critical part of a portrait. It then isolates the face by keeping distractions out of the frame. The telephoto also lets you do this while keeping a comfortable distance from your subject.

Wide Angles Up Close Give Striking Results

Many photographers shy away from shooting people with wide-angle lenses, especially up close. It is true that such a technique can give some wildly distorted looks to a face, which not all subjects appreciate. Yet you can also create striking images that grab you in a way that no other technique can do.

Be Careful of Focus with Telephotos

Remember that telephoto lenses have a limited area of focus. You need to be careful that your camera's autofocus is not focusing on the wrong parts of a face — for example, the tip of the nose or the ears. Work to be sure that focus is on the eyes. Sharp eyes really make a portrait more effective.

How to Buy New Lenses

Lenses can be a seductive attraction for a digital SLR owner. There are many on the market, and they all offer excellent results. That can make buying a new lens rather confusing. Each lens has its pros and cons related to specific

photographers or subject matter, yet that glass can be so attractive that photographers end up buying gear that is not really suited to them. Here are some ideas for what to consider when you want to add a lens to your bag.

Look at Your Limitations in Picture Taking

The first thing to consider is what you feel is limiting you as a photographer. Do you wish you could get closer to wildlife? Then look at long telephoto lenses. Do you find you cannot get back far enough to capture landscapes you like? Then look into wide angles. Base your choices on what is challenging your photography.

Hikon Asia and a single single

Be Wary of Other Photographers' Advice

It is quite easy to get impressed by another photographer's gear. They will tell you how great or bad a lens might be. Understand that lens choice and use is very personal, and what works for one photographer might be wrong for another. Look at how a lens really might fit your needs, not just how it works for another photographer.

Expensive Is Not Always Better

Expensive lenses are better than lower-cost lenses, right? Not necessarily. A lot of factors go into deciding on a lens. A lens with a large maximum aperture such as f/2.8 for a telephoto will be very expensive, yet it might not be as good as the same focal-length lens with a maximum aperture of f/4. Large maximum apertures can be very expensive to produce.

Big-Range Lenses Are Great, But Not for Everyone

If you want to travel with one lens, you might want to get one of the big-range zooms, such as 18-200mm. That gives you a lot of telephoto and wide-angle focal lengths in one lens. However, such lenses are also generally quite slow, meaning that the maximum f-stop, especially at the telephoto end, is small and lets in less light.

Chapter O

Indoor and Night Light Plus Flash

Conditions indoors change, from the time of day to the type of room to the kind of lights. With film, those varied conditions made indoor photography challenging. Night photography could be even worse. You never knew exactly what the light would do to contrast and color. Then, if you wanted to use flash in either situation, you could only guess what that would look like.

The digital camera has been a huge boon for dealing with the artificial light of indoors and night because you can actually see results as you take the pictures. This opens up so many possibilities. You can now shoot literally almost anywhere there is light and get good photos.

Deal with Artificial Light
Correct Color with White Balance
Using Appropriate Shutter Speed Technique 126
Brace the Camera for Sharpness
Understand How Flash Works
Dealing with Red-Eye
Avoid Flash Shadow Problems
Bounce Your Flash for More Natural Light

Deal with Artificial Light

Artificial light is the light you find indoors at home or at the office, in an arena, in a high-school gym, at night on the street, in a manufacturing plant, and in a restaurant. Basically, it is light other than sunlight. This light can be very interesting, but it often

presents challenges for the photographer, including sharpness, noise, contrast, light quality, and light color. Successful artificial light photography requires that you learn to deal with those conditions.

Deal with the Sharpness Issue

When you go inside and at night, light levels usually drop, which often requires slower shutter speeds for exposure. If you are not careful, such a change in shutter speed can make images less than sharp from camera movement that occurs from handholding a camera, or it can mean that subjects are blurred from their movement.

Light Color Can Be Interesting

The color of light can vary all over the place indoors and at night. This can be a problem when odd colors appear that are unattractive with your subject. On the other hand, the variation in light can be quite interesting and create images that cannot be captured in any other way.

What to Do with Contrast

Your eyes can see more detail in a contrasty scene such as night scenes than the camera can, but this goes beyond the night. You need to begin seeing like your camera and avoiding angles and compositions that favor a subject as you see it but look bad as a photograph because of too contrasty a light. Use your LCD to see what is really happening to your subject in that light.

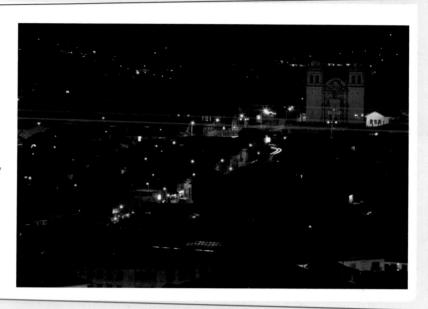

Why Noise Is Such a Problem

Low light usually means higher ISO settings, longer exposures, and often, a risk of underexposure. All of these can increase noise to unacceptable amounts. However, sometimes the only way to get the shot is to use a high ISO setting, and so you need to be especially careful of underexposure.

Correct Color with White Balance

Color differences in light are often magnified when you get out of the sun. Just try photographing a blond-haired person in a room with both fluorescent and incandescent lights; their hair shows off multiple colors from those lights. Artificial lights have so many different

colors, and their light affects subjects in both good and bad ways. You can continue to control this with white balance, as explained in Chapter 4, but the choices are not always clear cut indoors or at night.

Make Your Subject Look Good

If you are photographing a subject where color is critical, such as a person's skin tone, choose a specific white balance to match the light on that subject. A viewer of your photo will tolerate all sorts of odd colors if a key color looks good. Skin tone is one of those colors that really looks bad if it is off.

Create a Mood

Color affects mood. You will find that certain scenes look better with a color cast that influences the mood rather than a purely accurate color match. For example, lights at night often look better when they look a little warm, rather than white balancing the scene so that they are neutral.

Emphasize Colors in Light

When you have a scene with varied colors of light, each light appears differently when you change white balance settings. This is a good case for not using AWB, or auto white balance. AWB often gives you less effective colors because it tries too hard to compromise. Take some test shots and compare with different white balance settings.

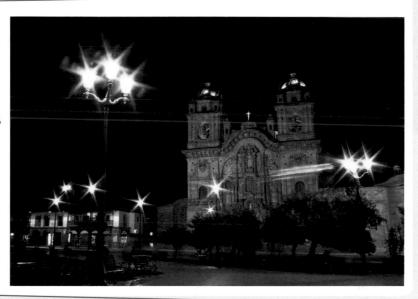

Try Custom White Balance

Sometimes the colors indoors or at night just do not look right, no matter what white balance setting you try. This may be the perfect time to use your camera's custom white balance setting. Use a white or gray card in the same light as the light that hits your subject, and white balance on it.

Unfortunately, camera manufacturers have not standardized this process and there are many ways this is actually done by the camera. Check your manual and you will usually find it is pretty simple to do. For example, the manual may suggest taking a picture of the white or gray card, and then telling the camera to remove the color in it.

Using Appropriate Shutter Speed Technique

Low light indoors or at night really taxes your camera's ability to use reasonable shutter speeds for sharpness. Even high ISO settings and wide-open lens apertures still result in slow shutter speeds. This is why night photos often do not look as sharp. The camera has too much

potential to move during a slow shutter speed. Flash eliminates that blur, but it also removes the feeling and mood of the light of a scene. There are some things you can do, however, to get sharper photos.

Watch Your Handholding Technique

How you hold your camera makes an especially big difference when the light is low. Be sure you have stable hand positions, with your elbows in, two hands gripping the camera, and the left hand supporting the lens of a digital SLR from below. Then press the shutter with a steady release — no jabs.

Use Wide-Angle Focal Lengths

Because wide-angle focal lengths can be handheld at slower shutter speeds than telephotos, they can be a real help when the light levels drop. Set your zoom to its widest as you shoot with slow shutter speeds. Never use telephoto focal lengths handheld in these conditions unless you have a lens with a wide maximum aperture and conditions are brighter.

Try Continuous Shooting

Set your camera to continuous shooting when the shutter speed gets slow. Then take a series of photos by just holding down the shutter. Very often, one of those shots will be sharp when the others are not. You are not moving much when such shots are made, and you cannot push the shutter release too hard.

Breathe Right

Many people think they should hold their breath when photographing with slow shutter speeds. That is a fallacy. Holding your breath can make you shake. Instead, use an old rifle shooter's technique: take a big breath, and then let it out slowly, releasing the shutter as you do.

Brace the Camera for Sharpness

Anything you can do to steady your camera will help you get sharper photos when shutter speeds are slow. As day changes to night and you begin to photograph under changing light, there will be some point, depending on the focal length of your lens, where shutter speeds

will be too slow to hold steady without support. A tripod can help and can be an important tool for shooting at night, but sometimes you just cannot use one. In these situations, you have other options.

Brace the Camera Against Something Solid

You can almost always find something solid to brace your camera against when you are inside. Think about the possibilities: door frames, chair backs, shelves, lamp stands, tables, and more. You can often shoot at quite slow shutter speeds when you have a camera pressed solidly against a bookshelf.

Try a Beanbag with a Screw

Beanbags are wonderful stabilizers for a camera. However, they slide easily from under the camera when the support area is not flat. Bogen markets a beanbag called The Pod that includes a tripod screw in the middle. This lets you attach the beanbag so that it stays right with the bottom of the camera, no matter where it is.

Look for Anything to Steady Your Camera

When you set a camera on a solid surface, it is often not aimed right. Look for anything that could be used to stabilize the camera at the shooting angle. For example, that could be rolled up paper, a shoe, or added fingers. Be imaginative, as long as the camera does not wobble.

Tripods Give Great Results

When you want the sharpest results in low light, you have to come back to the tripod. A tripod keeps the camera from moving during typically long exposures. If your camera has a two-second self-timer, use it when shooting long exposures on a tripod, as it helps the camera and tripod settle from any vibrations.

Understand How Flash Works

As interesting as indoor and evening light can be, after a while, you have to use a flash. A flash is a controlled light in color, direction, and intensity. It happens too fast for you to see anything other than a flash. The camera uses that flash to calculate an exposure that is correct for your subject and scene. In addition, you can always check your flash photos in the camera LCD to be sure exposure is right and to see if you have problems from the light of your flash.

The Camera Controls Flash Exposure

Cameras today have a lot of computing power built into them. A digital camera meters the results of a flash over multiple spots across the image area, compares those readings, and then calculates an exposure for the scene. The meter works like it does with normal exposures and can be overly influenced by light or dark subjects.

Alkon COOLPY 3.83mm 1

Digital Photography Needs a Pre-Flash

You may have noticed a double flash when you use flash with your camera. The camera sends out a first burst of light from the flash to see how much light is needed to create the exposure. It measures the light coming back from that flash and calculates the second, real exposure from that.

Accessory Flash Offers Options

An accessory flash is a separate unit that usually attaches to a flash shoe on top of the camera. All digital SLRs can use them, as well as some compact digital cameras. These units have a lot more power and versatility than a built-in unit. You can also get many kinds of accessories for them that help control your light even more.

In-Camera Flash Is Helpful but Limited

In-camera flash is very helpful because it means that you always have a flash with you. You can turn it on whenever you need more control to your light. However, it is small and does not have a lot of power. It may have little effect on subjects that are farther than about 10 to 15 feet away from the camera and you cannot modify much, such as by using a diffuser.

Dealing with Red-Eye

Anyone who starts photographing people at night with a flash will run into red-eye. Subjects start looking like they are possessed because their eyes glow red. This also happens with animals, but their eyes will have different colors, such as gold or green. Regardless, this is

rarely a desired effect. It is distinctly unflattering for people, making it terrible for party photos, and yet that is where red-eye is so commonly found. Red-eye settings for a flash can help, but there are other solutions, as well.

Red-Eye Is a Flash Effect

Red-eye comes from the flash and the flash alone. What happens is that in dark conditions, the pupils of eyes get larger. This allows more light to get inside the eye. If the flash is close to the axis of the lens, it reflects off the back of the eye at the camera. The flash is so much brighter than the scene that this effect shows up in the form of red eyes.

Canon The state of the state o

Flash Away from the Lens Reduces It

Red-eye occurs when the flash can reflect directly from the back of the eye to the camera lens. When the flash is away from that axis, its light cannot reflect directly back to the camera. The farther a flash is up from or to the side of the lens, the less likely you are to get red-eye.

Red-Eye Reduction Methods Sometimes Work

Digital cameras have a number of ways of trying to reduce red-eye. Cameras sometimes turn on a bright light, including quick bursts of the flash, to try to force pupils to contract. This can be distracting to a subject. Some cameras include built-in red-eye processing of the image file that can work quite well.

Bright Light Limits Red-Eye

Bright light makes people's pupils contract so the flash cannot easily reflect off the back of the eye. While cameras sometimes offer this, it can be distracting. It is often better to ask your subject to move to a brighter spot or to have them look momentarily at a nearby bright light before you take their picture.

Avoid Flash Shadow Problems

Flash is a very direct light. Because it comes from a small, but very bright, source, it is called a specular light source. Specular light creates hard-edged, very noticeable shadows. Such shadows are neither good nor bad, but when they are not controlled, you will find problem

shadows in your flash photographs. Shadows can be interesting or distracting, complementary or conflicting. You have to decide what you want to happen when you use flash for a scene.

Flash Creates Harsh Light

The first thing most people notice with flash is that the light can be harsh. This comes from both the contrast from bright to dark and the hard edge you will find along the boundary between shadow and light. You can use this for creative effect, but be aware that it can make subjects look too harsh.

Try the Night Flash Setting

Many digital cameras have a night flash setting. This balances the light from the flash with the existing light so that there is less contrast between the subject and the background. The background gets lighter and the image looks less harsh. This means a slower shutter speed, so be sure to hold the camera steady.

Off-Camera Flash Is a Possibility

If your camera can take an accessory flash, it can also use a dedicated flash cord. This cord lets you take the flash off the camera for better-looking shadows and a more dimensional light on the subject. Some cameras even have wireless capabilities so that you trigger a flash off camera without a cord.

Soften Your Flash for Good Effect A softer flash is flash that has its light spre

A softer flash is flash that has its light spread out. There are inexpensive, easy-to-use diffusers that you can attach to a flash to spread its light out. These reduce the light a little, but the camera automatically compensates for that. As the light spreads out, the shadows and their edges get less harsh.

Bounce Your Flash for More Natural Light

As you have seen, light coming directly from a flash can be harsh and unattractive. Yet this is not always necessary. Look at any fashion advertising; almost 100 percent of that is done with flash, but the flash is often bounced off of a big, reflective surface. That bounce makes the

light appear bigger, meaning that it spreads out considerably. It is this spread that makes subjects look better, with much more appealing light. The larger the light, the more sharp shadows tend to disappear.

Tilt Your Flash to the Ceiling

The quick and easy way to start using bounce flash is to get a flash that can tilt the actual flash tube part of the unit upward. Most accessory flashes allow you to do this. This immediately creates a large, gentle light source from above that is very natural looking. Be sure the ceiling is white and reflective or this will not work.

Turn Your Flash to a Wall

Many accessory flash units turn left and right. This allows you to bounce the flash off of a wall. Look for a white or light wall. If the wall has any color, it will show up in the photo. Warm white is okay. Bouncing light from the side gives you a very pleasant light with directional qualities to it.

Bounce Flash Makes the Light Gentler

Bounce flash works because the spread-out light on the wall or ceiling is large. This means that light can hit your subject from more angles, giving a gentle edge to shadows, yet still giving a very pleasing dimensional light. The bigger the bounce area, the gentler the light appears.

Off-Camera Bounce Changes Shadow Direction

With a flash-dedicated extension cord, you can get the flash off the camera and pointed wherever you need the light. You can then quickly go from a direct but very directional light, to instantly pointing the flash at the ceiling or a wall. That totally changes the light and gives better shadows.

Chapter 9

Editing and Organizing Your Photos

Taking photos today with a digital camera is pretty easy, and, once you own a camera and memory card, it costs nothing to take a lot of photos. However, many photographers are now running into a problem. What do you do with all of those photos?

With film, the prints and negatives were often stored in a shoebox, never to be seen again. With digital photography

and with a little time and effort, you can access your photos again and again.

hotos. aphers

o with

ed in a n

This chapter will help you get photos into your computer, and then edit and organize them so that you can access them easily in the future.

Import Photos to Your Computer
Organize Photos on a Hard Drive
Back Up Photos on a Second Drive
Using Photoshop Elements to Organize Photos146
Using ACDSee to Browse and Edit Photos 148
Using ACDSee to Organize Photos
Edit the Good from the Bad
Using ACDSee to Rename Your Photos
Create Quick Slide Shows with ACDSee 156

Import Photos to Your Computer

So you have taken a lot of photos, and now you want to get them from your camera to your computer. That will free up your memory card for new photos, and it will give you access to your images on the computer so that you can optimize and enhance them, use them for

e-mail, put them into a slide show, and much more. Once your photos are on the hard drive of your computer, you can do so many things with them. However, to start, you have to get them onto the computer.

The Computer Is Like a Filing Cabinet

Your photos may all be composed of electronic bits of information, but what you are really doing when you move photos from camera to computer is similar to putting them into a filing cabinet. The computer is a storage place, and you start using it that way by moving your photos into filing folders in the computer's hard drive, the "filing cabinet."

Download from a Camera

Getting your images from camera to computer is pretty easy. Most cameras come with a special USB cord that attaches to the camera and then to a USB port on the computer. Unless you have a very old computer, it will recognize your camera and its image files. You can then move the photos onto the computer's hard drive.

Download from a Memory Card Reader

Another way of downloading images is by using a memory card reader. This device plugs into a USB or FireWire port on your computer, and then you take your memory card from your camera and put it into the card reader. The computer recognizes the image files on your memory card and allows you to transfer them to the computer.

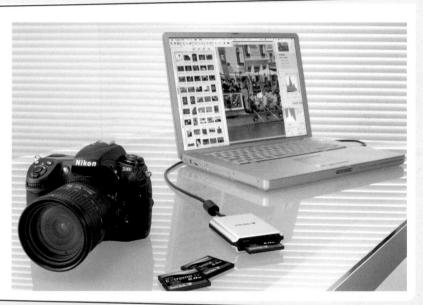

La Hoy

Advantages of a Memory Card Reader

A memory card reader offers a number of advantages over downloading from a camera. First, it is usually faster. Second, it needs no power and so it cannot run out of power while downloading, which can happen to a camera. Third, it takes up little space. Fourth, you never have to search for that "lost" camera cord.

Organize Photos on a Hard Drive

Once you get a camera or memory card hooked up to the computer, you are ready to copy your image files to the computer. How you organize your hard drive is like how you organize your filing cabinet. Better organization means you will be able to find your photos more easily in the future. It also helps in making the transfer of images to the computer because you have set up specific places for the photos.

Organize Photos on a Hard Drive

SET UP FOLDERS FOR YOUR PHOTOS

Keeping in mind the filing cabinet analogy, you can set up folders in your computer that are specifically for your photos. How you set these folders up should relate to how you file and find anything in folders so that you are comfortable with the system. You want to create folders and subfolders that help you find your photos more easily.

START WITH PICTURES

- Your operating system has a folder called Pictures or something similar that is already created in your documents folder.
- 1 Open the Pictures folder and create a new folder by right-clicking in the blank area and selecting **New Folder**.
- 2 Name that folder Digital Images.

This will be the home for your photos.

simplify It

What is the best way to organize photos on a hard drive? You need to create a system that you can work with and that you are comfortable with. If you simply use someone else's way of working and it does not fit you, you will end up not liking it and not using it for the best results. "A system you can work with" is something that fits your personality and way of thinking. It starts with where your folders are. Put them in a unique folder on your desktop, in a special folder in documents, or in a folder you create specially for your images on your hard drive. Any of these work, but only you know which is best for you. Then set up a structure of folders within that folder that also matches how you like to think and work.

CREATE YOUR OWN FOLDERS FOR EVENTS

Once you have a Digital Images folder, you can create specific folders inside that folder to help keep your photos organized.

- Create a new folder.
 This example creates a folder for the year.
- 2 Open the new folder and create subfolders for specific events or times you took pictures.

In this example, the 2008 folder contains folders such as Moms BD 3-18, Zoo Trip 4-08, and so on.

CLICK AND DRAG PHOTOS

Once you have specific folders set up, it is easy to drag and drop photos from your memory card or camera into those folders.

- Open the new folder where you want to place your photos.
- 2 Open the folder from your memory card and select the photos.
- **3** Drag them all into the new folder.

Back Up Photos on a Second Drive

One of the big worries for a lot of digital photographers is losing photos. Sure, fire or water damage could destroy traditional photos, but the digital image is so ephemeral that it seems riskier. There is no question that hard drives fail, computers die, and photos become

lost. The only way to protect yourself is to back up your photos in a location separate from your computer. Fortunately, this is not as hard as remembering to always back up as you photograph new subjects and scenes.

Back Up Photos on a Second Drive

EXTERNAL HARD DRIVES GIVE PROTECTION

External hard drives simply plug into a USB or FireWire port on your computer and instantly offer you a lot more storage. They are like adding extra filing cabinets. They are very affordable and come with a lot of empty gigabytes ready to hold copies of your photos from your computer.

CLICK AND DRAG FOR SIMPLE BACKUP

- Open your external hard drive.
- 2 Create a backup folder with a set of subfolders just like your Digital Images folder.
- 3 Click and drag your photos from the Digital Images folder on your computer's hard drive to the external drive by dragging a new folder into the right folder in the backup area.

Simplify It

How can I rename photos? The original names are not helpful. Elements, an image editing program, does not display file names by default, so if you are working there, you do not have to rename images. Later in this chapter you will learn how to use ACDSee, another program, to rename images. You can rename a single photo by selecting it in your folder in Windows Explorer, pressing F2 and typing in a new name. Typically, you want to rename a whole group of photos, though. You can do this in Elements. Select a group of images that you want to rename in the Organize module. Click File then click Rename to open the Rename dialog box. The name you type completely renames all selected photos.

BACKUP SOFTWARE CAN HELP

Backup software automates your backup. There are many software programs that do this. Time Machine on Mac computers works very well to ensure you have a backup. The Save N Sync program from Peerless Software is a simple and inexpensive way to copy images from one drive to another.

- 1 Choose the source folder.
- You can click the folder icon
 to find your original folder of images.
- 2 Choose the target folder. This is the new place on your backup hard drive. Use the same names for folders there as in the original folder to make the software run more efficiently.
- 3 Click Run Now to start.

TRY AN ADDITIONAL HARD DRIVE AWAY FROM THE COMPUTER

If you have some really important photos, you might want to keep them on a hard drive that is some distance away from your computer and its external drive. You can copy photos to an external hard drive for this purpose, and then move that drive someplace safe away from your original system.

Using Photoshop Elements to Organize Photos

Elements has a basic organizing module that can help you keep track of your photos on your computer. Having specific, named folders always helps, but then you have to open and search individual folders to find a specific photo. By having them organized in some way, you can find exactly what you need much faster. Elements includes several ways of doing this in the Organize module, such as using keywords, tags, and dates to help you find photos.

Using Photoshop Elements to Organize Photos

ELEMENTS STARTS WITH DATE

- 1 Bring photos into Elements from the Organize module by clicking File, Get Photos, and then From Files and Folders. In the resulting Get Photos dialog box, find the folder that needs to be imported by Elements. The program creates references to those files, but no file is actually moved.
- 2 Elements starts organizing by using the date the image was shot, a date imbedded into the file by the camera.

RATE YOUR PHOTOS FOR SORTING

- 1 Under each photo thumbnail is a set of five stars. You can rate your photos to sort them into groups by clicking the stars under the photos; for example, best images could have five stars, while those to be deleted could have one star. You can also click a photo and use the numbers 1 to 5.
- Sort your images by star rating by clicking the stars at the top right of all photos and using the drop-down menu next to it to control what is seen.

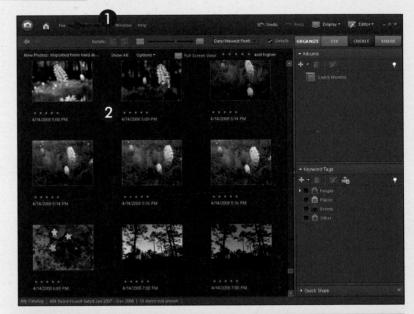

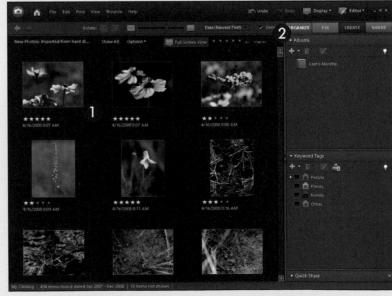

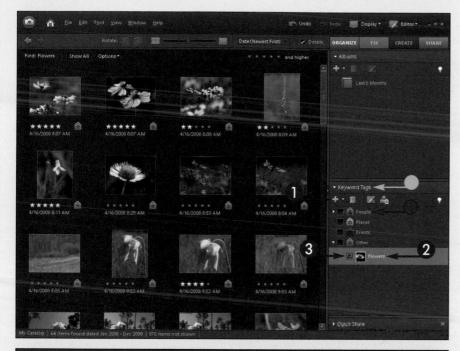

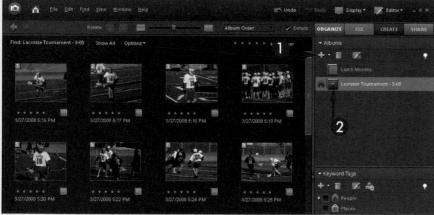

Remembering all the different options can be hard. Is there anything that can help?

Absolutely! Try the right mouse button. Right-click specific parts of the screen and you get a context-sensitive menu. If you are not sure about something regarding a photo, try right-clicking it, and the menu will be about photos. If you are not sure about something in a different part of the interface, right-click that, and a new menu will appear. You get a series of options for each, but the options are limited and apply to the area you are interested in.

ADD KEYWORD TAGS TO HELP YOU SEARCH

- The Organize panel contains a section called Keyword Tags. The preset tags are categories for keywords that Adobe has chosen.
- You can drag these tags onto your photos to tag them.
- ① Create your own keyword tags by clicking the plus sign (►).
- Type a keyword name in the resulting dialog box, and you can put this into an appropriate category. You can have separate keyword tags or you can put them into categories.
- 3 If you click the check box at the left of each tag, you only see photos that relate to that keyword.

GROUP PHOTOS INTO ALBUMS

- 1 Create albums for specific purposes. Albums are also on the right side, and you can create albums by clicking

 at the top of the panel. Make an album for a group such as family or church or for locations or other specific categories. Then click and drag photos into these albums, or albums onto photos.
- 2 Clicking the album icon reveals the photos in it.

Using ACDSee to Browse and Edit Photos

Elements offers the advantage of having organizing capabilities in a single program. However, it also has some limitations. Many Windows users will find ACDSee easier to use, with more features to help them browse, edit, and organize their photos. ACDSee is a standalone program available from ACDSystems, and

you can download a trial version from www.acdsee.com. You might find that Elements does the job for you, or you may discover that the ACDSee interface is easier to use.

Using ACDSee to Browse and Edit Photos

BROWSE PHOTOS

A browser allows you to view images on your hard drive, simply by navigating the folders. You do not have to import the files into the program so that it recognizes them, as you do with Elements.

- 1 Scroll down the Folders section to locate your images folder.
- 2 Double-click the folder.
- The photos appear in the central thumbnail area.

MAGNIFY PHOTOS

Digital cameras make it easy to take a lot of pictures, but what do you do with all of them? You can review them quickly in the central thumbnail area so that you can keep the good and delete the bad.

- 1 Position your mouse over an image.
- You instantly see a larger version of the image.
- You can change the thumbnail size of all images by moving this slider.
- 3 Double-click a photo thumbnail.

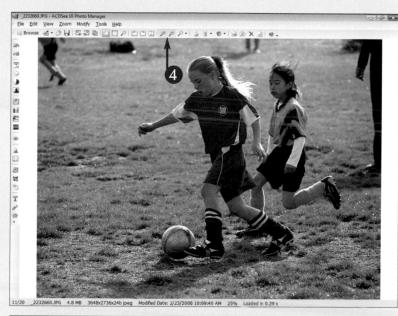

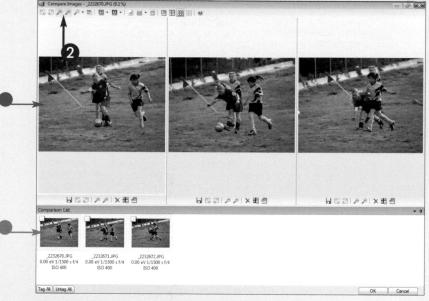

Simplify

The full-screen version of the photo appears.

- 4 Use the magnifier buttons in the toolbar to examine details in your photo.
- 5 Press the Esc key to return to the thumbnails.

COMPARE PHOTOS

1 Sometimes it is great to compare just a few images. To do so, select the images you want to look at more closely; click Tools and then click Compare Images.

While you can compare up to four images at a time directly, they get pretty small. Two or three images are better.

- The images appear in the Compare Images area.
- Any photos you have selected also show up in the filmstrip below.
- 2 Click the toolbar magnifier (2) to enlarge them all so that you can check them for things such as focus.

Comparing images can be tedious if you have to constantly enlarge them. Is there a better way to do this?

There are two things you can do. First, compare as few images at a time as possible. That keeps them bigger and easier to see. Second, use a large monitor with your computer. Anything less than a 19-inch monitor is going to make your photo work harder. Monitors have come down greatly in price, but do not buy the cheapest as such monitors do not show you accurate color. Get a large monitor and check its color and viewing angle at the store. Viewing angle refers to how well you can still see the colors as you move from side to side.

Using ACDSee to Organize Photos

Once you have photos on your hard drive, you need to have some way of organizing them so that you can find them again. You probably remember how frustrating that was with film. As you shoot more digital photos, you will discover that finding a specific photo becomes more challenging. ACDSee offers many ways to

help you sort and organize your photos across folders and even hard drives, including other methods that you will learn as you use the program. Use the method that is most appropriate to your needs; you do not have to use them all.

Using ACDSee to Organize Photos

RATE YOUR PHOTOS

One quick way to categorize photos is to give them a rating. In ACDSee, you can rate them from 1 to 5 very quickly by pressing Ctrl and then the number for each rating. Press Ctrl + 0 to remove ratings.

As soon as you add a rating, you see a small circle with the appropriate number by the thumbnail.

SORT YOUR IMAGE FILES

- 1 Sort your images by clicking the **Sort By** button at the top of the thumbnail display.
- Sort your photos by such things as your rating, the filename, and the time the photos were taken. By adding ratings to your photos and using the Sort By feature, you can quickly arrange your photos in order of your preferences.

Editing and Organizing Your Photos

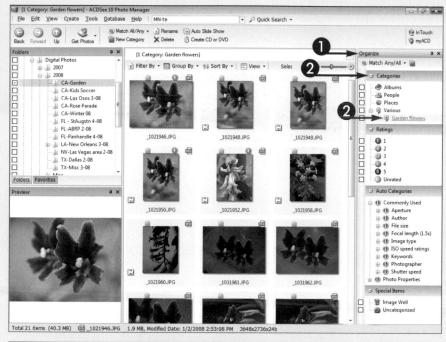

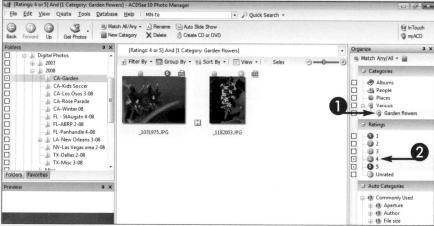

USE CATEGORIES

- Organize your photos using the Organize panel on the right side of the ACDSee interface.
- 2 Choose one of the available categories.

You can also create a new category that is more appropriate to your subject by right-clicking the word Categories, or make a subcategory by right-clicking an existing category.

You can drag and drop the category icon onto your photo or selected photos to put them into the category. These categories go across folders throughout your files.

FILTER YOUR FILES

Once you add ratings or categories to your photos, you can quickly sort them.

- Click a category in the Organize panel to see all of the images that you have tagged in that category.
- 2 Find photos that you have rated throughout your files by clicking the rating numbers.

What does workflow for digital photography mean?

Workflow has become a faddish word about the process of working with images from input to output from the computer. If you follow the order of techniques shown in this book, you are following a specific workflow or process that works well for most photographers. You can certainly modify this as needed to better match your specific needs, but the process or workflow here will get you started.

Edit the Good from the Bad

Although it is useful to rate photos and separate good photos from ones that you want to delete, many photographers do not do this because the process is intimidating. What if they erase the wrong photos? Yet, if you do not get rid of photos, you will clutter your hard

drive with excess photos that take up space, which makes it harder to sort through those photos. It is very time-consuming and difficult to try to put huge numbers of photos into categories.

Get Rid of Exposure Problems

First, look for exposure problems. Overexposed, washed-out photos are never going to look right, no matter how much time you spend working on them. Underexposed, overly dark photos are also a problem, as they become filled with noise and are always frustrating to work on. Get rid of these images.

Watch for Focus Problems

No matter how much you like that photo from your last trip, if it is out of focus, you will never really fix it and it will never be a satisfying image. Blurry photos from the wrong shutter speed are difficult for most people to view. Delete photos like these, as they are just going to be problems for you.

Remove the Shots with Bad Timing

Everyone takes photos that show bad facial expressions, with objects you never saw blocking the view on one side of the composition, or with the subjects in awkward positions. If you keep these photos, you will always be making excuses for the shots. Delete them, as they will never be effective photos.

| 3232672.9FG -ACMB 364862736:24b josq Modified Date: 2/23/2008 10:14:18 AM 25% Loaded in 0.24 s

If You Do Not Like a Photo, Delete It

Many photographers hang onto certain photos because they think they might need them someday. They are usually shots of a favorite person, pet, or location, but the subject is not flattered by the shots. Or for whatever reason, you just do not like them. Trust your intuition and get rid of the photos, as you are unlikely to ever really use those images.

Using ACDSee to Rename Your Photos

The filenames for your photos coming from the camera are neither imaginative nor useful. The filename IMG03877 is not going to help you locate that photo later. By renaming your photos, you can search for those names to help you find them later. You can create whatever

names help you describe your photo, but short names are easiest to deal with, both when searching and when looking at names in an image folder. You can always search for specific filenames by using your computer's operating system, as well as ACDSee.

Using ACDSee to Rename Your Photos

RENAME YOUR PHOTOS WITH ACDSEE

ACDSee makes it very easy to rename your image files.

- 1 Select the photos you want to name, or select all of them by pressing Ctrl + A.
- 2 Press F2.

This opens up the Batch Rename dialog box. Here, you can change the filenames in several ways, including a complete change or a change that adds information to an existing name.

USE NEW NAMES THAT HELP YOU FIND PHOTOS

One way to help you find photos is to give groups of images unique names that have letters or words that trigger your memory. ACDSee already has a search function to help find photos by date, so adding the date will not help you.

3 Try things like state abbreviations, people's names, and abbreviations for events that are memorable.

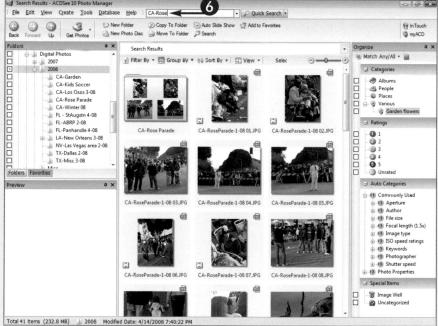

CREATE A STANDARD NAMING SYSTEM

Set down a few simple "rules" for your names and keep them consistent.

- 4 For example, you could put the location first, then a brief note about the subject, and then use the chronological numbers that ACDSee creates automatically if you tell it to.
- **5** Chronological numbers are used when you type in the # symbol. You can also tell ACDSee which number to start with.
- The resulting filenames might look something like this: CA-RoseParade-1-08 01, CA-RoseParade-1-08 02, CA-RoseParade-1-08 03, and so on.

FIND PHOTOS WITH QUICK SEARCH

Once your photos have names, you can use the ACDSee Quick Search function to find them very quickly. You simply start typing the filename (you do not have to know the whole name). For example, you can type in the first part of the name, and the program displays all of the files with that name.

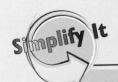

Do I have to rename photos?

Renaming photos can be very helpful in giving you another way of searching for specific images. However, you do not have to ever rename a photo if you do not want to. If you structure your files so that they have very specific folders for each downloaded set of images, and you structure those folders in a way that makes sense to you, having specific file names is not a necessity. You can find images through your file folder names and visually browsing them in ACDSee or Windows Explorer. Names are only useful as a way of defining specific groups of photos to make them easier to find.

Create Quick Slide Shows with ACDSee

Slideshows were a popular way of showing images in the days of film. Then, you had to choose between slide and print film for the photography, which would limit your ability to

make a slideshow. Now you can use your digital files for making prints, creating slideshows, and much more. Slideshows are a great way to show off your photos.

Create Quick Slide Shows with ACDSee

START AUTO SLIDE SHOW

1 Select the photos you want for a slideshow.

You can use all of the photos in a given folder by not selecting any of them, or you can select any number of photos by ctrl + clicking them.

2 Choose Auto Slide Show from the Tools menu.

Your selected images play in full-screen view on your monitor, based on the default settings.

ADJUST TIMING AND CHANGE TRANSITIONS

- 3 Change the default settings for the slideshow by clicking Tools, and then clicking Configure Auto Slide Show. This opens the Slide Show Properties dialog box.
- 4 Choose a transition in the Basic tab. Be wary of using too many transitions, and keep them simple so that your photos are the stars of the show.
- **5** Choose timing for the slides in the Image Delay field.

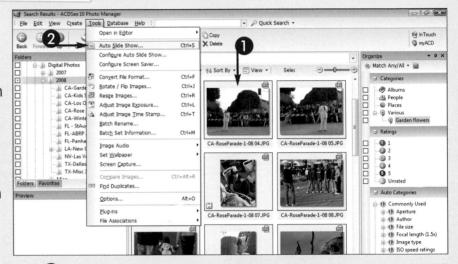

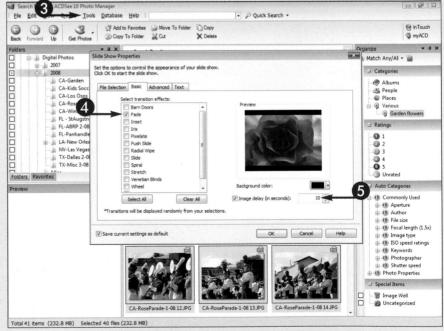

Editing and Organizing Your Photos

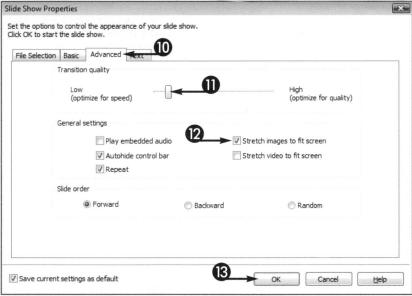

ADD TEXT

Personalize your slideshow by adding some text to it.

- 6 Click the Text tab.
- **7** Choose to display text at the top as header text.
- **8** Choose to display text at the bottom as footer text.
- Type in your text, such as the location of a trip, the name of an event, or even who did the photography.

CHANGE ADVANCED SETTINGS

- Select the Advanced tab to make further adjustments to the Slide Show Properties.
- Transitions often look better with the Transition quality slider set to high, but this can slow down your computer (a problem if you are trying to display photos quickly).
- 12 If you want the whole screen filled with your photo, choose the **Stretch images to fit** screen option.
- (3) Click **OK** to start your slide show.

Should I mix vertical and horizontal photos in a slideshow?

Traditionally, photographers would often combine vertical and horizontal photos in a slideshow as projected by a carousel projector or other device. That worked because the vertical and horizontal photos were the same size. However, with computers, you either show the image on a screen, which is horizontal, or from a digital projector, which also gives a horizontal form. The result is that horizontal photos are larger than verticals. This can make vertical photos look not as good. That does not mean you cannot use both, but it does mean you need to watch how the two formats interact with specific images.

Chapter LO

Basic Adjustments with Photoshop Elements

Photoshop Elements is a program designed to help you adjust your photos on your computer. Elements, as it is often called, is made to be photographer-friendly, yet it is also quite powerful in what it can do. Still, it does take some practice to be able to use it at its best. In this chapter, you will learn some key ways of working with the Edit features of the program.

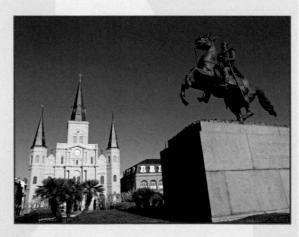

In addition, the developers of Elements have included many helps built into the program as well as an excellent Help menu. Look for text in many dialog boxes that helps you make decisions on what to do.

How Elements Is Arranged
You Cannot Hurt Your Photos
Crop Your Photos for Better Images
Fix Crooked Horizons166
Fix Gray Photos
Make Dark Photos Brighter
Correct Color Easily
Try Black-and-White
Size the Picture for Printing
Size Photos for E-mail
Sharpen the Image

How Elements Is Arranged

When you first open Elements, you get a set of choices, including Organize and Edit. When you choose Edit, you access the processing or editing features of the program. This is where the real work on a photo occurs, from adjusting its brightness to correcting its color. It helps to

understand how the interface is arranged, and how you can change it to make it work for you. Any changes you make to the interface are automatically saved so that Elements will open in that configuration the next time you launch the program.

How Elements Is Arranged

OPEN ONE OR MORE PHOTOS

- 1 Open photos just as you would open files from any program, by clicking File and then clicking Open to display the Open dialog box.
- 2 Select the images you want. You can open more than one photo to work on, and they all appear in the filmstrip area at the bottom of the interface, though you will have to minimize them to keep them there. You can also open photos from the Organize module of Elements. Keep in mind that your computer may slow down if you open too many files.

USE THE TOOLBOX AND TOOLBAR

When a photo is open in the main work area, you can adjust it in many ways.

- The toolbox of colorful tools at the left is important for many of the adjustments that you will make to your photograph.
- All of these tools have settings that you can change in the toolbar at the top.
- Click the down arrow at the far left of the toolbar to reset the tool.

OPEN WORK PALETTES

- The right panel of the Elements interface holds important work palettes and is called the Palette Bin.
- 3 Click the **Window** menu to open and select additional palettes.
- 4 An important palette that you will want to open is the Undo History palette as described in the next section. Any palette that you open will be remembered by Elements the next time you launch the program.

CHANGE THE PALETTE BIN

- Palettes first open as floating palettes.
- **5** To add palettes to the Palette Bin, click the **more** button to display a drop-down menu.
- 6 Click Place in Palette Bin when Closed, and close the palette.
- Remove a palette by clicking the top bar and dragging it out of the Palette Bin. Then click the more button at the top right and uncheck the Place in Palette Bin when Closed option, and close the palette.

What is the best way to arrange palettes?

You will find the best way for you as you work with Elements. You may find that you need a certain layout of palettes when you first start, and that you change this as you get more proficient with the program. Basically, you want to leave open and in the Palette Bin those palettes that you use all the time and close those that you do not. You can always open a closed palette at any time by clicking **Window** and choosing it from the menu.

You Cannot Hurt Your Photos

Photographers sometimes get really worried about adjusting their photos in Elements, as they are afraid of hurting their photos. However, you can relax. It is very difficult to do permanent damage to a photo as you work on

it in Elements. There are many safety features that let you back up and undo everything that you do. You really cannot hurt your photos as long as you do not save over your original files.

You Cannot Hurt Your Photos

KNOW THE UNDO COMMAND

The Undo command is ubiquitous in computer software — Ctrl/# + Z. Use those keystrokes whenever your adjustments go astray, and you will undo whatever you just did to your photo. Use this command again, and you will back up further in your chain of adjustments.

PROTECT YOUR ORIGINAL

When you open a photo into Elements, get in the habit of using the Save As command.

- 1 Click **File** and then click **Save As**.
 - This opens the Save As dialog box, which allows you to use a different name and save a copy of your file. That protects your original.
- 2 For a working file, save your image as a Photoshop (.psd) or a TIFF (.tif) file, not as a JPEG (.jpg) file.

Warning: Never open an original file and click **Save**. That would save over your original file. Always use **Save As** for the first save.

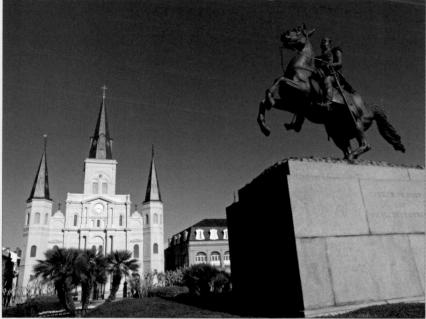

USE YOUR UNDO HISTORY PALETTE

If the Undo History palette is not open, click Window and then click Undo History to open it.

The Undo History palette shows you a list of what you have done to a photo and allows you to reverse adjustments you have made.

Click any point in the palette to see what was happening to a photo as you made adjustments.

SAVE AS YOU GO

Once you like what is happening to your photo, save it to be sure you embed those changes into the working copy of your photo. You can simply press Ctrl/#8 + S to save an image at any time. You can also use the Save As command to save versions of your changes if you think you might need choices among different versions of your photos later.

Why should you save in TIFF or Photoshop (PSD) and not JPEG?

A JPEG file is a compressed file format that can lose quality if it is opened, worked on, and resaved. Each time you open it, it has to be reconstructed from the compression; then, when you save it, it is recompressed. That can degrade the quality of your photo. On the other hand, you can open, work on, and resave TIFF and PSD files as much as you want; there is no quality change to the image file. JPEG can be used as a final, archiving format for an image that you simply want to save for the future if you need to conserve storage space.

Crop Your Photos for Better Images

Often you have a good start to a photo, but the whole image is not quite right. There may be just too much space around your subject so that you cannot see details as well as you would like. Or perhaps there is some distracting element that snuck into a corner of the photo,

such as someone's foot or hand, which just does not belong in the image. And there are always those photos that look crooked and need to be straightened. Elements lets you take care of all of those problems.

Crop Your Photos for Better Images

FIND THE CROP TOOL IN THE TOOLBOX

■ Use the Crop tool to crop your image to show only the part you want. The Crop tool (□) is placed at about the middle of the toolbox, next to the letter T. This tool looks like a traditional designer's physical crop tool. It is an upside-down L placed on top of a right-side-up L, with a line going from the lower-left to the upper-right corner.

DRAG A BOX AROUND YOUR SUBJECT

- Use the Crop tool like a cursor.
 Click at the upper-left corner of the part of the photo you want to keep, and then drag diagonally through the desired area. You do not need to be precise, as you can then click and drag the edges in and out as appropriate until you get the cropped area you need.
- 2 Click the green check mark (☑) to accept the change, or just press

 Enter or Return. To cancel your crop, click the red circle/slash icon (☑) or just press Esc.

EXPERIMENT WITH CROPPING

The outside of the crop box dims so that you can see what you will keep after cropping. Try different amounts of cropping before committing to the crop. Even if you do commit and you do not like it, you can just press Ctrl/# + Z to undo it, which takes you back to the original photo. Then try a new crop and see how the photo changes.

CROP TO A SPECIFIC SIZE

- Click the Aspect Ratio dropdown menu on the toolbar to display a list of some standard photo sizes.
- 2 You can also type specific sizes in the Width and Height fields.
- Remember that you can reset all of these settings by clicking the arrow at the far left and choosing Reset tool.

When should I crop to a specific size?

Generally, it is best to crop to a specific size at the end of your work in Elements, not at the beginning of the process. Crop out problems at the beginning so you do not have to deal with them as you work. If you crop to a specific size at the start, you may be limiting your sizing options later. You may discover that you want to have two different sizes. In that case, it is best to work with a master image that has had minimal cropping done to it.

Fix Crooked Horizons

Sooner or later, every photographer gets crooked photos. The most common of this type of problem is the tilting horizon. For example, the line of an ocean, lake, or distant horizon appears to take a downward slope that is not part of reality. Or you may find that your kids

have a distinctive lean in the photo that is not normal to the way they stand. When everyone shot with film, you just had to live with this problem. Luckily, this is no longer the case and is very easy to fix in Elements.

Fix Crooked Horizons

ROTATE THE CROP BOX

- 1 Create a crop box around the area of your photo that you want to keep. Move your cursor outside of the crop box. The cursor turns into a curved arrow (♠). By clicking and dragging that curved arrow, you can rotate the entire crop box to adjust and straighten your photo.

LINE UP HORIZONS WITH A STRAIGHT LINE

Horizons need to be straight and horizontal. Your crop box has two straight, horizontal lines.

- 3 Move the top or bottom line of your crop box close to your tilted horizon. Click outside the box to rotate the crop box to match the line and the horizon.
- 4 Drag the edges of the box until you get the crop you want, and click < ...</p>

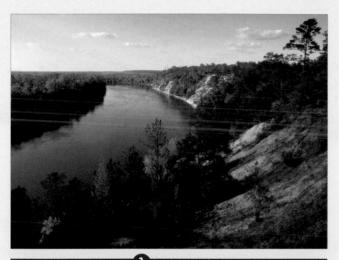

Your horizon is straightened.

USE CUSTOM ROTATION FOR PRECISE CONTROL

Sometimes it is tough to get the horizon or other lines exactly right. Elements offers a control for very precise adjustment.

- 1 Click Image.
- 2 Click Rotate.
- 3 Click Custom.

The Rotate Canvas dialog box opens.

4 Type in a number for the rotation. At first, you may have to guess, but if it is wrong, you can just undo it and do it again until it is right. You have to crop the edges when you are done.

FIX PHOTOS IN THE WRONG ORIENTATION

Most cameras today record orientation information with the photos so that they come out correctly horizontal or vertical. However, sometimes that does not work. You can correct that very simply.

- 1 Click Image.
- 2 Click Rotate.
- 3 Click 90° Left or 90° Right as appropriate for your photo.

Fix Gray Photos

Often photos come from a digital camera with a distinct gray cast to them. They do not have the lively contrast and color that photographers have come to expect from film. This is not a digital shortcoming, but simply a way that camera designers have worked to hold detail

in dark areas. You simply have to adjust the photo to bring that contrast and color back. This can make an especially big difference in a print. With photos that you really care about and from which you want larger prints, always check these adjustments.

Fix Gray Photos

TRY AUTO SMART FIX

Images coming straight from the digital camera are not always adjusted properly. Smart Fix is a one-step way to correct this.

- 1 Click Enhance.
- 2 Click Auto Smart Fix.

Although this may give you exactly what you want, it sometimes overcorrects color, and so you can undo the step and try another control.

TRY AUTO CONTRAST

- 1 Click Enhance.
- Click Auto Contrast.

You will often find your photo comes to life without colors being changed. This can be very important if you have a color cast that is part of the scene, such as the light from a sunrise or sunset. You want the warmth of this type of scene to show in your photo.

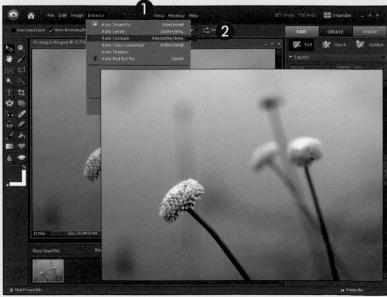

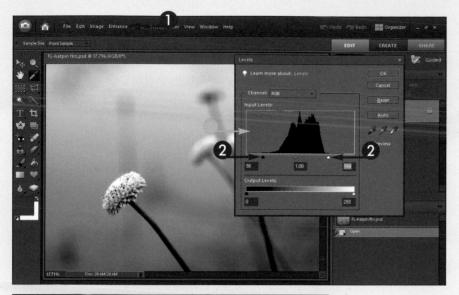

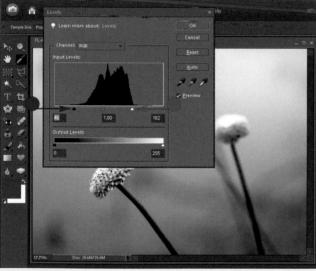

USE LEVELS FOR MORE CONTROL

Click Enhance, click Adjust Lighting, and then select Levels.

The Levels dialog box opens.

- Look at the black and white sliders under the graph, which is called a histogram.
- 2 On most photos, you can move the black slider to just under the upward slope of the graph at the left, and the white slider to just under the upward slope at the right. This is a good adjustment to start with on most photos.

BLACK IS SUBJECTIVE, WHITE IS LIMITED

- The black slider in Levels is very subjective. You can get dramatic results as it moves to the right.
- The white slider, though, quickly washes out highlights if you move it too far to the left. To avoid this, use the ideas in the next section, "Make Dark Photos Brighter," to brighten a photo more if you do not get enough brightness with Levels.

Why should I be concerned about black in a color photo? Printers, your monitor, and other ways of displaying photos all have the capability of showing a solid black tone. If your image does not have that solid black, your photo will never use the full range of color and tone that is possible from that display. The result is that your image will look gray and less contrasty and will have less than satisfactory color. Some photographers will refer to this as setting the "blacks" because you are

changing the black tone of many individual dark areas across the photo.

Make Dark Photos Brighter

As good as digital camera metering systems are, they never make every exposure perfect. Sometimes you get photos that are too dark and you need to brighten them. Or you have a photo that gets too dark from the Levels adjustments you made in the previous section.

It may seem logical to use the Brightness/Contrast feature, located in the Enhance menu, but this is a very heavy handed control and not appropriate for most overall adjustments. Elements has controls that can make your photo look much better than that.

Make Dark Photos Brighter

TRY THE AUTO CONTROLS

- 1 Sometimes for a dark photo, all you need to do is use the Auto Smart Fix command in the Enhance menu. This can really help with very dark and underexposed photos.
- You can also try Auto Levels in the same menu. Both commands work, but they affect colors differently. You may find that you need one command for one photo, and the other command for another.

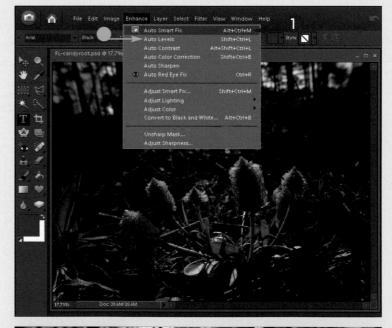

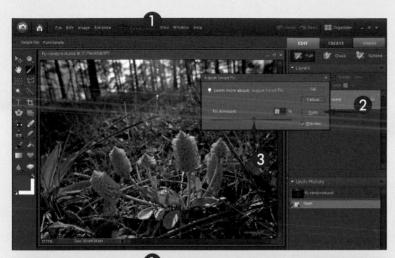

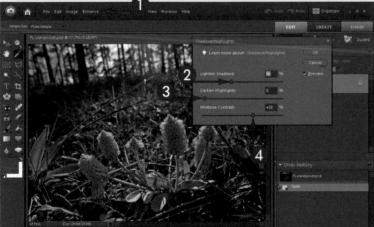

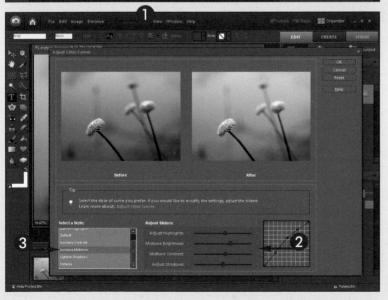

USE ADJUST SMART FIX

If you find the auto controls do not give you the results you want, then you can use an automated control that can be adjusted.

1 Click Enhance and then click Adjust Smart Fix.

The Adjust Smart Fix dialog box opens.

- **2** Click the **Auto** button to get started.
- 3 Move the Fix Amount slider to get just the right amount of change needed for your photo.

TRY SHADOWS/HIGHLIGHTS

You might find that the whole photo is dark or that just the shadows are too dark.

1 Click Enhance, click Shadows/Highlights, and then click Adjust Lighting.

The Shadows/Highlights dialog box opens.

- 2 Adjust dark areas with the **Lighten Shadows** slider.
- 3 Correct bright areas with the **Darken Highlights** slider.
- 4 Fix midtones with the **Midtone Contrast** slider.

Be wary of over-adjusting shadow brightness, as it makes the photo look odd.

EXPERIMENT WITH COLOR CURVES

You can use Color Curves for photos that are just a little too dark.

1 Click Enhance, click Adjust Color, and then click Adjust Color Curves.

The Adjust Color Curves dialog box opens.

- 2 Adjust the sliders to brighten or darken specific tones, such as highlights or shadows.
- 3 You can also try one of the preset adjustments in the Select a style list.

Correct Color Easily

Color is an important part of photography, so when a photograph has color that is off in some way, people notice this. In the days of film, this was always a problem, especially when skin tones went bad or hair changed color because of fluorescent lights. This is no longer true. You can correct problem colors quite easily in Elements and make any subject look its best under all sorts of light.

Correct Color Easily

TRY AUTO SETTINGS TO CORRECT COLOR

1 When there is a slight color bias to your photo, you can click **Enhance**, and then click **Auto Color Correction**.

Elements examines all the colors in your photo and tries to balance them.

If Auto Color Correction does not work, undo it and try Auto Smart Fix or Auto Levels. Both of these features also try to remove color problems.

REMOVE A COLOR CAST

Remove an unwelcome color cast in your photo by clicking Enhance, clicking Adjust Color, and then clicking Remove Color Cast.

The Remove Color Cast dialog box opens. This is a very simple tool.

2 Click something white, gray, or black that should be neutral in color.

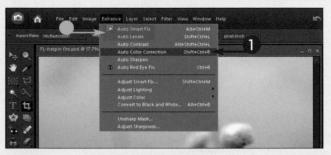

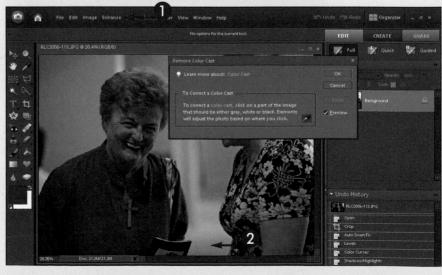

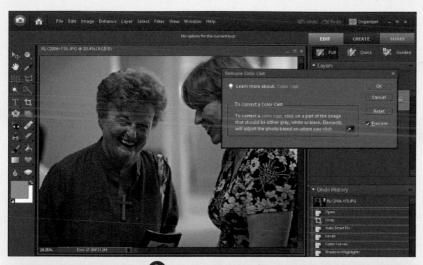

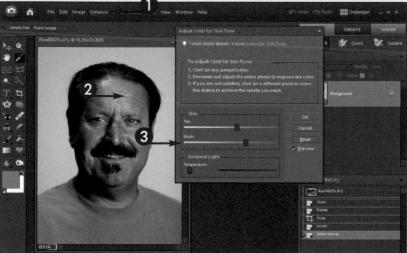

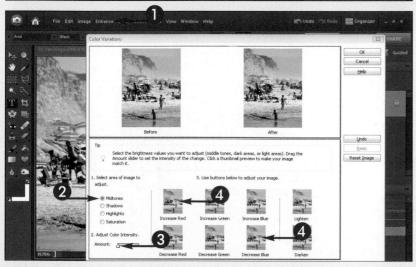

Elements removes the color cast. You may have to click in multiple places to get it right.

ADJUST SKIN COLOR

You can fix problem skin color by using the Adjust Color for Skin Tone feature.

Click Enhance, click Adjust Color, and then click Adjust Color for Skin Tone.

The Adjust Color for Skin Tone dialog box opens.

- 2 Move your cursor over the person's skin, and click.
- 3 The Skin and Ambient Light sliders become active so that you can adjust the color of the skin. You may have to click in more than one place to get the color right.

WARM UP A PHOTO

In general, photos look better warmer than cooler. You can use the Color Variations feature to warm up a photo, as well as to change overall color in other ways.

Click Enhance, then click Adjust Color, and then click Color Variations.

The Color Variations dialog box opens.

- 2 Select Midtones.
- **3** Move the Color Intensity slider to the left to lower the intensity.
- 4 Click the Increase Red and Decrease Blue boxes to warm up the photo.

Try Black-and-White

Black-and-white photography used to be the most common way to take pictures. It has a very long history in photography, but it nearly disappeared when color photography became popular. Today, black-and-white is enjoying renewed interest. Because it is no longer

common and because it does not show the world as realistically as color, it is used as a more artistic medium by many photographers. It is very easy to change color to black-and-white in Elements.

Try Black-and-White

TRY TO REMOVE COLOR FOR SIMPLE CONVERSIONS

- 1 Click Enhance.
- 2 Click Adjust Color.
- 3 Click Remove Color.

This is a simple way to convert color to black-and-white. There are no sliders or options; you just select it and it works. Use this method for images that do not have a lot of important colors or that have good contrast from light to dark.

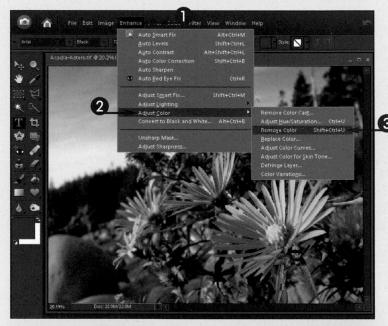

BETTER CONVERSIONS COME FROM CONVERTING TO BLACK-AND-WHITE

The Remove Color feature is very limited in its results, but it is fast and easy.

- Click Enhance, and then click Convert to Black and White.
- 2 The resulting dialog box gives you a whole set of controls to help you change colors into tones of gray.
- **3** Try the Select a style list for specific conversion results.

CONVERT COLORS INTO CONTRASTING TONES OF GRAY

Contrast is a critical part of black-andwhite photography. Green and red are very different, but they can look the same in black-and-white.

4 Try changing the **Adjustment Intensity** sliders to affect how the colors red, green, and blue are changed into lighter or darker tones of gray.

ADJUST CONTRAST OF THE BLACK-AND-WHITE IMAGE

Because contrast in a black-and-white photo is so important, you should make an additional adjustment after converting from color. Often, all you need is the Auto Contrast or Auto Levels feature, found in the Enhance menu.

In the Adjust Color Curves dialog box, try changing the contrast by using the Increase Contrast style and by making the dark tones darker and the light tones lighter.

Size the Picture for Printing

The size of your photo depends on the megapixels of your sensor. This size affects how large you can make a print. Cameras today are perfectly capable of making large prints that easily match anything that 35mm film can do.

There is a certain range of print sizes that are possible with the pixels that come from your sensor. You can then make photos larger or smaller by having Elements change the number of pixels in the image file.

Size the Picture for Printing

CHOOSE A PRINTING RESOLUTION

The first thing to do is to find out how large or small you can make your print based on the original pixels of your image.

- 1 Click Image, click Resize, and then click Image Size.
- 2 Be sure that the **Resample Image** option is unchecked.
- 3 Type in 200 ppi for the resolution, and note the size of your print shown in the Document Size area. Then use 360 ppi. These are printing resolutions that work for all photo printers and the size dimensions that result show you how large or small you can make your print based on existing pixels.

CHOOSE A PRINTING SIZE

- 4 Specify a size for your print in the Document Size area of the dialog box.
- Ensure that the resolution is between 200 and 360 ppi.
- 6 Click OK.

You cannot make specific sizes for a print here, because you need to size all sides proportionately. If you need a specific size, then size one side to what you need, and crop when you have finished sizing.

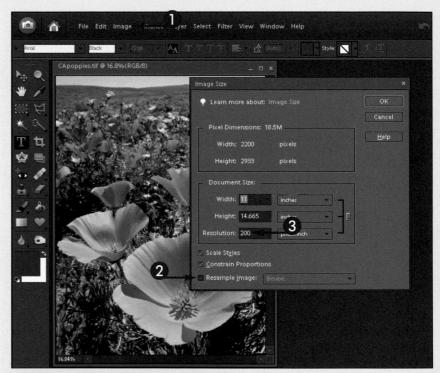

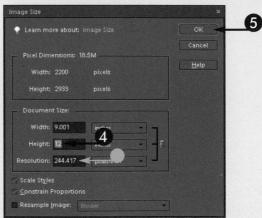

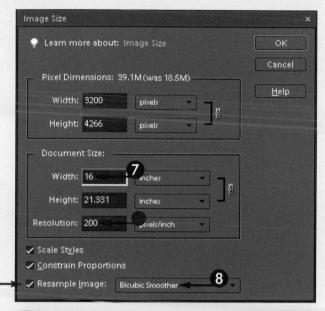

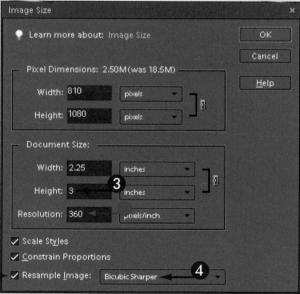

ENLARGE AN IMAGE FILE

Your photo might not be as large as you want, even when you use a resolution of 200 ppi.

- 6 In the Image Size dialog box, check the **Resample Image** option.
- Leave the resolution at 200 ppi.
- Specify a key width or height that you need. The other dimension changes automatically.
- **8** In the Resample Image drop-down menu, choose **Bicubic Smoother** in order to add pixels for enlargement.

SHRINK AN IMAGE

You may also find that your photo is not as small as you need, even when you use a resolution of 360 ppi.

- 1 Repeat Steps 1 to 5.
- 2 In the Image Size dialog box, check the **Resample Image** option.
- Leave the resolution at 360 ppi.
- **3** Type in the key dimension needed.
- 4 In the Resample Image drop-down menu, choose **Bicubic Sharper**.

Simplify It

Which photos should I resize?

Not all photos will resize well, so save yourself some trouble and only resize photos that look good resized. This is influenced by a number of factors. A photo that is over or underexposed will frequently not look good at larger sizes. If your photo has a lot of noise, it will often resize poorly. And finally, blur from camera movement will sabotage the resizing of most images, so do your best to get the image sharp when you take the picture.

Size Photos for E-mail

Adding a photo or two to an e-mail is pretty easy to do. It is also a little too easy to add image files in their original size, which clogs up people's mailboxes and slows down their computers. Avoid annoying your friends and family. Resize your photos to a proper size for

e-mail. This allows you to send the images with fewer problems, and they will be happier to get photos from you. This is especially important if your recipient does not have a broadband connection to the Internet.

Size Photos for E-mail

MAKE YOUR PHOTOS SMALL

1 Click Image, click Resize, and then click Resize Image.

The Image Size dialog box opens.

- 2 Check the Resample Image option, and select Bicubic Sharper in the Resample Image drop-down menu.
- 3 Type 100 in the Resolution field.
- 4 For the long side, specify either a width or height in the Document Size section. The short side changes automatically to reflect this amount.

This example uses a width of 8 inches, which is a large viewable image for e-mail. If you need smaller photos, you can use 6 inches.

PRINTABLE FILES CAN BE E-MAILED

If you want your recipient to be able to make a print, you need to size the image a little differently.

- **5** Type **150** in the Resolution field.
- 6 Use a size of 6 inches for the width or height of the long side.

This gives an approximately 4x6inch print at an acceptable resolution for printing, but in a file size that is appropriate for an e-mail.

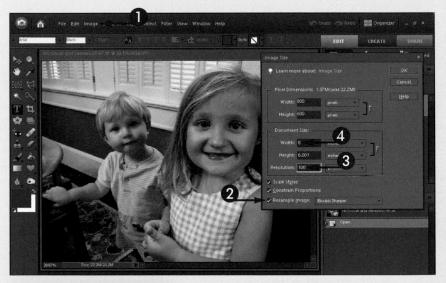

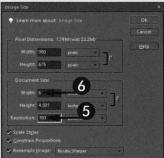

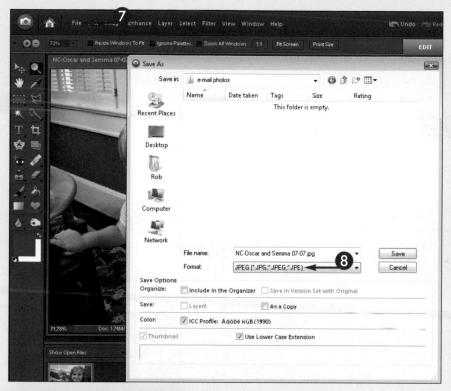

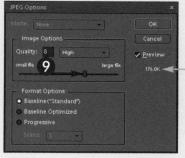

SAVE YOUR PHOTOS AS JPEG FILES

Click File, and then click Save As.

The Save As dialog box opens.

8 Save the photo as a JPEG file. JPEG compresses your image file so that it becomes much smaller and is easier to e-mail. The JPEG format removes redundant data that can be reconstructed later when the file is reopened.

CHECK YOUR FILE SIZE

The JPEG Options dialog box opens.

- 9 Choose a compression level for JPEG using the Quality slider. Use middle or high numbers whenever you can.
- To keep your e-mail small, try to keep your files to a maximum size of approximately 200KB. If you are sending many photos, keep the maximum size lower.

I can just attach my camera's photo files to an e-mail. Why should I not do that?

Digital cameras today have large image files, even when you are using compressed files in the JPEG format. You can easily have a single file that is 1 to 2MB in size. That is a very big file for e-mail and will frustrate a lot of people who get it. It may be easy for you to attach and send, but it is not so easy for the recipient to deal with on the other end. Keeping your files small for e-mail will make your recipients much happier to get photos from you.

Sharpen the Image

Your camera probably already applied some sharpening to your image file. Still, most of the time when you work on a photo, you need to sharpen it after you have sized it for printing. Sharpening is designed to bring the most detail

out of your image file, based on the original sharpness of the photo. It is not designed to make a fuzzy or blurry photo sharp. Sharpening blurry images usually makes them look worse.

Sharpen the Image

TRY AUTO SHARPEN

- 1 Elements has a number of sharpening tools that you can use to good effect. However, the one-click **Auto Sharpen** feature in the **Enhance** menu does such a good job that you often need little else.
- Magnify your photo with the Zoom magnifier tool (<a>Image <a>Image <a

FOR PRECISE CONTROL, USE UNSHARP MASK

You can use the Unsharp Mask feature when you need to control sharpening carefully.

1 Click **Enhance**, and then click **Unsharp Mask**.

The Unsharp Mask dialog box opens. This control lets you adjust:

- **2** Amount or intensity of the sharpening.
- 3 Radius or width of the sharpening.
- **4** Threshold or how noise is sharpened.

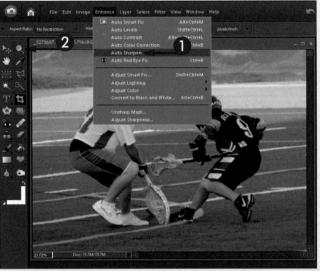

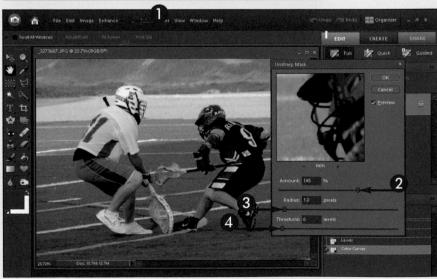

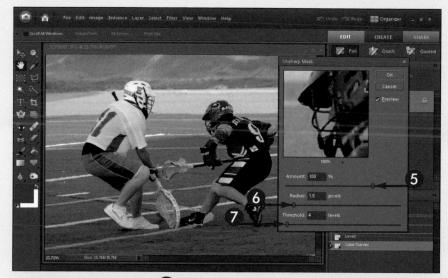

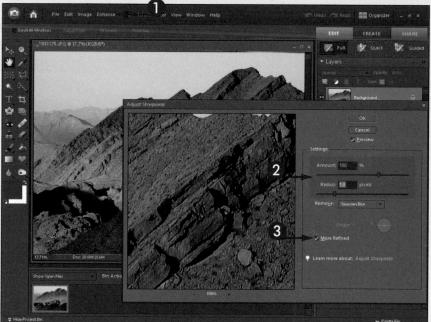

NUMBERS YOU CAN USE

Photographers use a lot of formulas for Unsharp Mask adjustments, and they all work for different purposes. Be careful not to sharpen too much.

- **5** Try a range of **120** to **180** for Amount, depending on the subject.
- **6** Try **0.8** to **1.5** for Radius, depending on how large your photo is.
- 7 Try 3 to 6 for Threshold, depending on the amount of noise in areas such as the sky and out-of-focus tones.
- 8 Click the main image with your cursor to set what is seen in the small preview.

TRY ADJUST SHARPNESS

The Adjust Sharpness feature is an advanced smart sharpening tool.

1 Click Enhance, and then click Adjust Sharpness.

The Adjust Sharpness dialog box opens.

- 2 Specify Amount and Radius settings, just like Unsharp Mask. Because it does not have a Threshold setting, Adjust Sharpness is not good with images that have a lot of noise. However, it does a very good job for detailed subjects such as landscapes.
- 3 Check the More Refined option to make edge sharpness look better.

I like sharp photos. How much sharpening can I apply?

There is a tendency among many amateur photographers to oversharpen photos. Oversharpening makes an image look harsh and damages fine tonalities that can give life to a subject. Sharpening should be applied to give a good looking sharpness but not a harsh sharpness. How do you know how much to use? Follow the guidelines given in this section, and then look closely at the photo as you change the sharpening sliders. When the edges and tonalities in the photo start looking harsh, with strong, unattractive contrasts, then sharpening is too strong. Sharpening can only be used to get the most from a photo that was sharp to begin with. It cannot make a fuzzy photo look sharp.

Additional Controls with Photoshop Elements

Photoshop Elements is a very powerful program. You do not have to know everything about Elements in order to get the most from it, but you do need to know those tools and adjustments that work best with your subject matter, for your specific photographic needs. You cannot learn those things by simply reading a book. You have to practice and see what works best for you.

You can learn to use Elements by working with your own photos. That experience, including both your successes and failures, will help you use the program better and faster. Work with your good and your bad photos, so that you can get to know the program's tools.

Using Selections to Isolate Adjustments 184	
Modify Your Selections	
Increase Color Saturation without Problems	
Darken Specific Areas of a Photo190	
Lighten Specific Areas of a Photo	
Darken Edges for a Traditional Look	
Clone Effectively	
What Layers Are About	

Using Selections to Isolate Adjustments

When working on a photo, you will often notice that only part of the photo needs to be adjusted, not the whole image. It would be great to be able to adjust only that part and nothing else. Fortunately, with selections, you can do exactly that. For example, you can make

something darker or lighter, or adjust its color, in isolation from the rest of the photo. Selections create a kind of fence around a part of your photo, allowing adjustments to occur inside that fence, but never outside. You can press or /% + D to remove a selection.

Using Selections to Isolate Adjustments

SHAPE SELECTIONS AND HOW SELECTIONS WORK

- 1 Near the top of the toolbox, you will find selection tools such as the Rectangle/Square and the Ellipse/Circle marquees. Click and hold the icon to see both tools.
- 2 Select a tool, and then click and drag the corresponding shape in the photo.
- 3 You can now change anything inside the selection without affecting the rest of the image.

TRY THE POLYGONAL LASSO

- Next to the shape selection tools are the Lasso selection tools: Freehand, Polygonal, and Magnetic. Click and hold the icon to see them.
- With the **Polygonal Lasso** tool (S) selected, click from point to point around a shape. Back up with the Backspace or Delete key.
- 3 Finish by clicking the start point.
- 4 Now you can precisely define where your adjustment occurs.

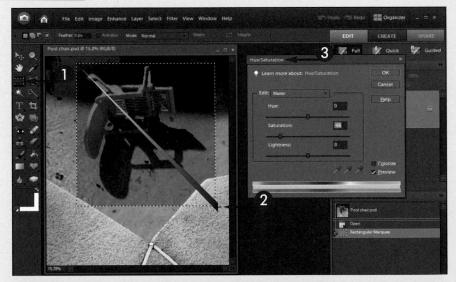

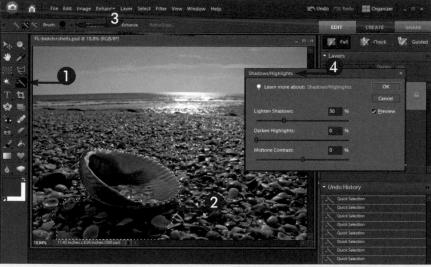

USE THE MAGNETIC LASSO TOOL WITH STRONG EDGES

- Use the Magnetic Lasso tool (a) to automatically find edges of shapes when there are strongly contrasting edges.
- 2 Click near an edge, and then move the cursor near that edge; the magnetic feature finds the edge for you.
- **3** Finish by clicking the start point or by double-clicking.
- 4 You can now change anything inside the selection, such as the hue or saturation of a color with Hue/Saturation, without affecting the rest of the image.

MAKE QUICK SELECTIONS

- Use the Selection Brush tool
 (►) for another automated, easy-to-use selection tool.
- 2 With the Selection Brush tool, you literally brush a selection over a photograph.
- **3** Change the brush size in the top toolbar to best fit your subject.
- 4 You can now change anything inside the selection without affecting the rest of the image.

What about the Magic Wand tool? It is an automated selection tool, too, right?

It is indeed. The Magic Wand tool () creates a selection based on areas of similar color and tone when you click one area. Using it is fairly simple. You select the tool from the toolbox, and then move your cursor over your photograph. Find an area of similar tone or color, and then click. This will then create a selection based on that color or tone. Change **Tolerance** in the options toolbar to get more or less of the area selected by typing in larger or smaller numbers respectively. Use **Contiguous** to select based on tones and colors that are contiguous or together. Uncheck **Contiguous** to select similar tones and colors throughout the whole photo.

Modify Your Selections

You can modify both your selections and how you work on a selection in ways that will make selections easier for you. You can build up a selection with a series of smaller selections, and you can change the edge so that any changes will blend better. Selections can take a lot of time and make your work more tedious; these tips will help you work with selections faster and more efficiently. Remove any selection by clicking Select and then choosing Deselect.

Modify Your Selections

ADD TO A SELECTION

As you make a selection, you will often find that you cannot select the whole area at once.

- 1 By pressing the Shift key as you use your selection tool, you can add to a selection.
- 2 You can also click the Add to Selection icon (■) in the toolbar so that you can add to a selection.

SUBTRACT FROM A SELECTION

Conversely, you may find that while the selection contains what you want, it catches too much of an area. You can change the selection without starting over.

- 1 By pressing the Alt Option key as you use your selection tool, you can subtract from any selection.
- 2 You can also click the Subtract from Selection icon (■) in the toolbar to subtract from a selection.

COMBINE SELECTION TOOLS

Sometimes you will find it easiest to create a selection one step at a time, adding a little here and subtracting something there. These additions and subtractions are often best done with different selection tools.

- 1 Try using the Magic Wand tool (▲) on an area that contains similar colors and tones.
- This example uses the tool on a sky, with the **Contiguous** option unchecked to get the sky behind the trees.
- 2 Use the **Polygonal Lasso** tool (☑) with the Alt / Option key to remove selection areas that are not part of the area you want.

BLEND YOUR SELECTION EDGE

By default, selections have a rather hard edge that does not blend well into the adjacent areas of a photograph. You can make your edges blend with feathering.

- Click Select and then choose Feather.
 The Feather Selection dialog box opens.
- 2 Use a small number for edges that need a sharper edge, and a large number for edges that need to gradually change from one area to another. It is hard to give specific numbers as they will vary depending on the content and size of your photo.

Increase Color Saturation without Problems

When photographers first discover the Hue/Saturation feature, they often get carried away. This tool seems to magically transform dull colors into bright and vibrant colors. Unfortunately, that often means garish and

unattractive photos. Also, overuse of this feature can result in more and very unattractive noise in an image. You can use this control effectively to give good color without garish results.

Increase Color Saturation without Problems

GO EASY ON SATURATION

The Hue/Saturation adjustment lets you change colors as well as their intensity.

Click Enhance, click Adjust Color, and then click Adjust Hue/Saturation.

The Hue/Saturation dialog box opens.

- 2 The **Hue** slider changes the colors.
- 3 The **Saturation** slider adjusts the intensity of colors. The Saturation slider is rather heavy handed; adjusting more than 10 to 15 points usually causes problems.

CHANGE COLORS INDIVIDUALLY

The trick to using the Hue/Saturation feature is to make stronger adjustments to individual colors.

- 4 In the Hue/Saturation dialog box, click the **Edit** drop-down menu to display a list of colors.
- 5 Choose a color; Elements limits the adjustment of Hue, Saturation, or Luminance to just that range of color.

TELL ELEMENTS EXACTLY WHICH COLOR TO CHANGE

- 6 Refine your color even more by moving your cursor out onto the photograph. The cursor changes to an eyedropper (*).
- Now place it over the color you want to adjust, and click once.
- The color scales at the bottom of the dialog box shift to match that color so that changes are more specific to it.

USE A SELECTION TO FURTHER LIMIT COLOR CHANGE

Even when you tell Elements to restrict its color changes to a specific color range, those colors may appear throughout your photo.

- **9** Make a selection first to limit any change to a specific area.
- Open the Hue/Saturation dialog box and limit its adjustments to a specific color as described in Steps 4 and 5.

I used to like the bright colors of Fujicolor film. Can I use Hue/Saturation to get those colors?

The answer is a cautious, "Yes, but..." Those colors come from more than saturation. The film had a strong black base and deep contrast, which increased the intensity of the color. You can get that with Levels by how you set the blacks and whites as described in the section "Fix Gray Photos" in Chapter 10. After that, use Hue/Saturation, but avoid using Saturation alone for more than 15 points adjustment. Then tweak individual colors as needed to get your colors bright and "colorful" like Fuji film.

Darken Specific Areas of a Photo

Ansel Adams is a name that most people recognize as one of the great landscape photographers. He created wonderful black-and-white photographs of scenery that are still popular today. One of the things he did in the

traditional darkroom was to darken parts of a photo so that it was more balanced and better emphasized and highlighted the subject. You can do the same thing with Elements, and you never need to find a darkroom!

Darken Specific Areas of a Photo

LOOK AT YOUR WHOLE PHOTO

Take a look at your whole photo, and decide which areas are too bright.

1 Find parts that look out of balance with the rest of the photo because their brightness attracts the viewer's eye away from your subject. These are the areas you want to darken, and you want to do this so that the changes blend well with the whole photo.

SELECT THE AREA FOR DARKENING

- 2 Select the area or areas that need darkening.
- 3 Open the Feather Selection dialog box so that you can feather the edge so that it blends.
- 4 If there is a strong edge, the feather can be very small, maybe only a few pixels. If there is no strong edge, then use a large feather to blend the change more, for example 50 to 60 pixels or more.

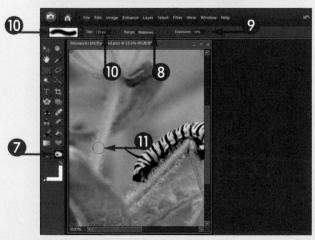

USE BRIGHTNESS/CONTRAST FOR DARKENING

5 Click Enhance, click Adjust Lighting, and then click Brightness/Contrast.

The Brightness/Contrast dialog box opens. In general, you should not use Brightness/ Contrast for overall changes to your photo. For darkening, the **Brightness** slider gives a very good result.

6 Move the slider left until you like the change.

USE THE BURN TOOL FOR SMALL AREAS

- 7 For small areas, choose the **Burn** tool (♠) in the toolbox. It is near the bottom and it must share the same space as the Sponge and Dodge tools. If you do not see the Burn icon, then click and hold on the **Sponge** tool (♠) to see it.
- **8** Set the tool to a range that is appropriate to the tones you want to affect.
- Use a very low exposure of 5 to 10 percent.
- **10** Use a soft brush sized for the area.
- 11 Paint over the area to darken it using multiple strokes.

Lighten Specific Areas of a Photo

Ansel Adams lightened parts of a photo to bring out detail in certain areas without making the whole photo lighter. After getting the overall image right, Adams would create wonderful, majestic photographs by selectively lightening and darkening the photo. He would sometimes spend days in the darkroom just perfecting the right proportion of light and dark areas. You can do the same thing with Elements in considerably less time.

Lighten Specific Areas of a Photo

LOOK FOR DETAIL THAT IS TOO DARK

Take a look at your whole photo, looking for where darkness is working against your image.

1 What places are too dark? You can brighten these areas, and like the "Darken Specific Areas of a Photo" section, you can do it in such a way that changes blend well with the whole photo.

SELECT THE AREA FOR LIGHTENING

- 2 Select the area that needs to be lightened.
- **3** Open the Feather Selection dialog box so that you can feather the edge so that it blends.
- 4 Just as with darkening, if there is a strong edge, the feather can be very small, maybe only a few pixels.

If there is no strong edge, then use a large feather to blend the change more, for example, **50** to **60** pixels or more.

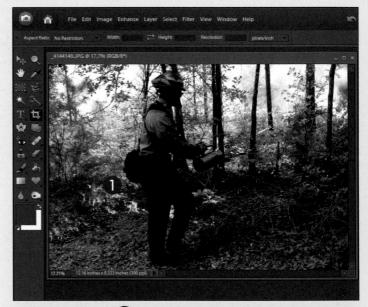

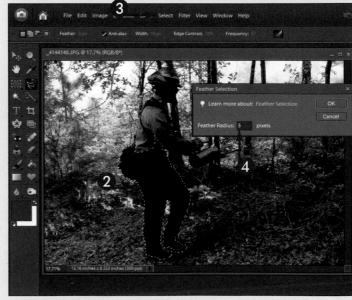

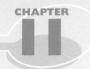

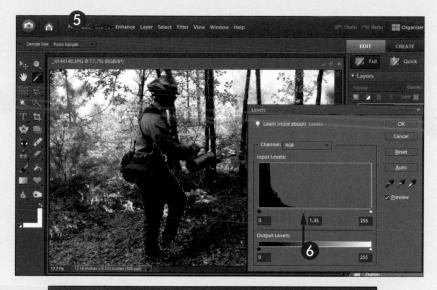

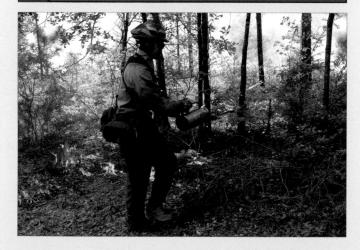

USE LEVELS FOR BRIGHTENING

5 For brightening, the Brightness slider in the Brightness/Contrast dialog box gives a very poor result. Instead, click **Enhance**, then click **Adjust Lighting**, and then select **Levels**.

The Levels dialog box opens.

6 Move the middle slider to the left until the area looks properly brightened. The left and right sliders also work, but in general, the middle one looks best for this change.

USE THE DODGE TOOL FOR SMALL AREAS

- Select the **Dodge** tool (■). This tool lightens an area, and shares space in the toolbox with the Burn tool (■). Neither one works well for large areas, as they tend to make the areas look blotchy.
- 8 Set the tool to a range that is appropriate to the tones you want to affect.
- 9 Use a very low exposure of 5 to 10 percent.
- **10** Use a soft brush sized for the area.
- 11 Paint over the area to lighten it in multiple strokes.

Darken Edges for a Traditional Look

Ansel Adams often said that it was very important to darken the edges of any print to keep the viewer's eyes on the image. Darkening the edges really enlivens your photo and gives it a richness and depth that you cannot get in

any other way. It took a bit of work in the old darkroom, but it is really simple to do in Elements. You also have a lot of control over how dark you want the edges.

Darken Edges for a Traditional Look

SELECT THE INSIDE OF THE PHOTO

- 1 Select the **Elliptical Marquee** tool ().
- 2 Make a selection that includes most of the inside of the photo.

While you have a selection tool active, you can also click inside the selection and move it around to a better place, if needed. You can also use the **Polygonal** Lasso tool () to make this sort of selection more precisely.

GIVE THE SELECTION A BIG FEATHER

You want the edge darkening to really blend nicely, and so you need a big feather to soften the selection edge.

- **3** To display the Feather Selection dialog box, click **Select** and then choose **Feather**.
- 4 Set at least a 100-pixel feather (this could be as high as 200 pixels if you really need a gentle effect on a large photo). How much is really a matter of personal taste.

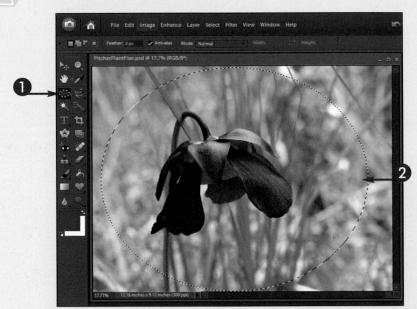

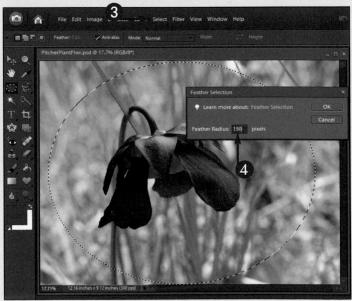

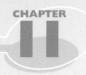

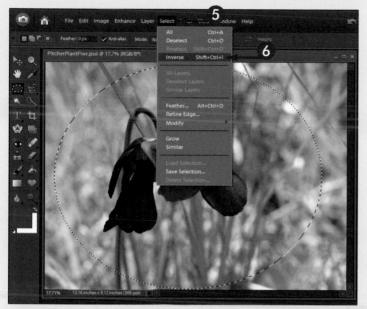

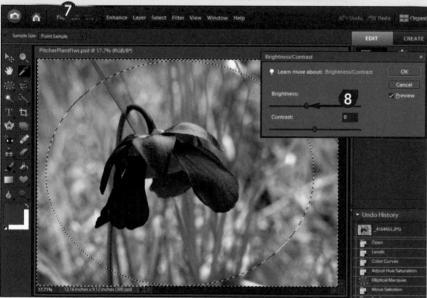

Simplify It

INVERT THE SELECTION

Right now, your selection is still making the center of the photo the active area. You need to invert this so that you can adjust the outside edges of the photo.

- 6 Click Select.
- 6 Click **Inverse**. This inverts your selection so that it now goes from the inner selection line to the outside edges of the photo.

USE BRIGHTNESS/CONTRAST TO DARKEN THE EDGES

Click Enhance, and then click Adjust Lighting.

The Brightness/Contrast dialog box opens.

8 Move the **Brightness** slider to the left. How much depends on the photo, but usually an amount of **20** to **30** works well. You can hide the selection line to better see the effect by pressing Ctrl/# + H. Remember that you hid the line, though.

The quick answer to that is, "It depends." Ansel Adams would vary how strong this effect was depending on several factors, and you can, too: how bright the overall photo is (lighter images usually need less); how dramatic you want the effect (it can range from subtle to very dramatic and still be "right"); and your subject (some subjects look better with darker edges, some with lighter edges). It is helpful to go to the Undo History palette and click back and forth between dark edges and no dark edges to see what the effect is really doing to your image. See Chapter 10 for more about the Undo History palette.

Clone Effectively

Photos get stuff in them that do not belong with your subject. This could be as simple as dust on your sensor, which would show up as dark blobs in the sky. Or you could have a nice scene with trash in it that you did not see when you took the photograph. Or perhaps there is

an extraneous hand in the photo that is distracting. You can get rid of all of these distractions by using the Cloning tool. Cloning simply copies a part of a photograph from one place over another to cover an offending problem.

Clone Effectively

SET UP THE CLONE STAMP TOOL

- 1 Select the Clone Stamp tool (), just below the middle of the toolbox. It looks like a little stamp.
- 2 Select a soft-edged brush to help your cloning blend; use the brushes with the fuzzy edges shown in the sample brush in the options toolbar just below the menus.
- 3 From the toolbar at the top, select a brush size that is appropriate to the problem area you want to fix. You can see this because your cursor turns into a circle whose size represents the brush size.

SET YOUR CLONE FROM POINT

- Magnify the area that you need to clone, using the Zoom Magnifier tool () at the top of the toolbox.
- **5** Check the **Aligned** option in the toolbar, as this will align the clone from point with your actual cloning as you do the work.
- 6 Press the Alt Option key and click once to set a point that the cloning tool can clone from. This is the point from which it copies pixels.

CLONE IN STEPS

- 7 Click to clone from the set point over your problem area.
- **8** Clone in steps; do not simply paint. Cloning in steps allows the cloning to blend better.
- As you clone, change the clone from point whenever you start seeing duplicating patterns. It is a good habit to change that point as you go.

CHANGE YOUR BRUSH SIZE

Work to make the cloning blend better with the problem areas. This is very easy to do by using the bracket keys, and and and located to the right of the letter on your keyboard. The key makes the brush smaller, while the all key makes it bigger. Clone over the already cloned area using a different-sized brush if you start seeing problems.

I have heard that you have to be careful of cloning artifacts. What are they?

An artifact in a photo is something that is not in the original scene or subject, but gets into the photograph because of the technology or technique used by the photographer. A cloning artifact is a repeating pattern or texture caused by cloning that pattern or texture to a new place nearby. You avoid it by changing your clone from point and your brush size. Watch for such artifacts as you clone and immediately make those changes.

What Layers Are About

Layers are beyond the scope of this book, but you may have noticed that they are an important part of the Elements interface. The Elements interface includes a Layer menu as well as a Layers palette. Layers can be worth learning at some point because they can make

a lot of adjustments faster and more efficient. This section will introduce you to what they are and how they can help you. Everything shown in this chapter and Chapter 10 can be done with layers.

What Layers Are About

LAYERS ARE LIKE A STACK OF PHOTOS

Photographers often get intimidated by layers. However, layers become less intimidating if you think of them as photos stacked on top of each other.

1 The Layers palette shows that stack from the side, and just like a real stack, you can move layers up and down, remove them, and cut them into pieces.

LAYERS ISOLATE ADJUSTMENTS

- Do whatever you want to a layer.
- Your changes affect nothing else in the photo.

If you use selections with a layer, you can really isolate an adjustment so that you affect only one thing and nothing else.

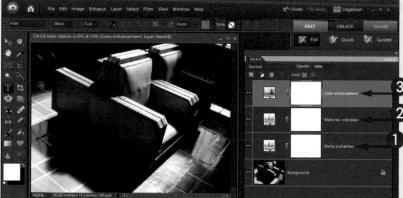

ADJUSTMENT LAYERS ARE NON-DESTRUCTIVE

- 1 Adjustment layers use the same controls shown in Chapter 10, but they are like filters that go over a print.
- 2 Adjustment layers change the look of your image.
- The original image is not altered, and so no pixels are damaged. You can go back and make changes as often as you want without problems. You can also experiment and just delete an adjustment layer to remove a change without hurting the photo.

LAYERS WORK BEST STEP BY STEP

As you add layers, follow the same steps that you have seen in this book, one adjustment at a time, as follows:

- 1 Use Levels for adjusting the blacks and whites in your images.
- Use the middle slider in Levels for midtones, as Color Curves is not an adjustment layer.
- 3 Use Hue/Saturation for color.

Rename each layer by doubleclicking the name and typing a descriptive name. This allows you to quickly understand what your layers are doing to the photograph.

Can all these layers be saved with a photo and be worked on again if I reopen a photo?

That is another great advantage of layers: They can be saved with your image file. Use **Save As** to save your photo as a Photoshop (PSD) file. This will automatically keep your layers when you save your image. You can save layers to a TIFF file, but this is not a good idea because this makes that TIFF file less usable. Only Adobe products recognize layered TIFF files, yet a TIFF file is a ubiquitous format that is recognized by any program that uses photos. If you want to save your photo as a TIFF file, flatten it first by using the **Flatten Image** command found in the **Layer** menu.

Chapter [2]

Printing Photos

Photographic prints have long been a great way of sharing not only your photographs, but also your experiences, your trips, your family, and so many other parts of your life. A good print is fun and a joy to have. A bad print is disappointing and sad.

This chapter will give you some ideas on how you can consistently get better prints from your photographs.

Printing is a craft. This means that it takes some practice to really get good at it.

Start with a Good Photo for a Good Print 202
Calibrate the Monitor
Using Photo Printers with Elements 206
Set the Printer Driver Correctly 208
Make the Right Paper Choice 210
Make a Good Print
Add Text to a Print

Start with a Good Photo for a Good Print

Often you will hear people say that they do not have to worry about digital photography because they can fix their photos in Photoshop or Elements. Stay away from that line of thinking! That gets you into trouble and

prevents you from getting the best prints possible. Fixing images that were not shot properly from the start can be a frustrating and time-consuming process. In the end, the image is of less quality, and is usually difficult to print.

Blurry Photos Get Noticed with Larger Prints

Sharp photos make a difference. You can actually get away with a slightly blurry photo if it is printed small. But if you want to print it large, or you want to crop a part of a photo and print it larger, you will really see that blur. A larger image also makes the blur larger for everyone to see.

Washed-Out Exposures Look Bad in a Print

When a part of a photo is washed out from overexposure, the white of the printing paper shows through the photo. This really adds empty detail to the picture. Most of the time, this becomes a distracting part of a print, which is not something you want. Avoid this with proper exposure.

Dark Exposures Make Noise More Obvious

When you adjust a dark exposure to be brighter so that it prints well from Elements, you also reveal noise. The darker the photo, the more noise will be obvious. This becomes an increasingly glaring problem as a print gets larger. Once again, avoid this with proper exposure.

Dark Exposures Cause Color Problems

Another problem with photos that are too dark is that as you brighten them in Elements, you can have problems with colors. Those colors may lose some of their richness and tonalities, and this often shows up in prints as harsh contrast, unless you spend extra time on the image in Elements.

Calibrate the Monitor

If you want to make the most of your computer and digital photography all the way to a good print, consider calibrating your monitor. Monitor calibration does not guarantee a good print, but it gives you a consistent, predictable work environment that you can use more effectively to get a good print. Monitor calibration used to be complicated and expensive. That is not true anymore. Very affordable devices are available that work with automated wizards, making the process very easy.

Calibration Tools Start the Process

Monitor calibration needs a set of calibration tools. These come in a package that includes a sensor or "puck" that sits on your monitor to read it, and software to automate the whole process. You can easily share these tools with friends and other photographers, as you will probably only calibrate every few months.

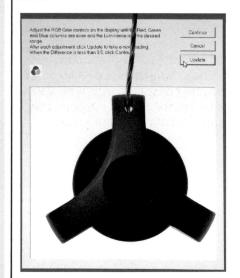

The Puck Goes on the Monitor

The calibration sensor is often called a puck because it looks like one. It sits on your monitor over a location defined by the software. The software also tells you to do a few simple things with your monitor controls before you start using the puck to read specific colors.

Software Automates the Work

Once everything is set up, you tell the software and sensor to start working. The software sends carefully chosen colors to the monitor under the puck, and the sensor examines them. Then the software compares the information it has received to its database of what colors should look like.

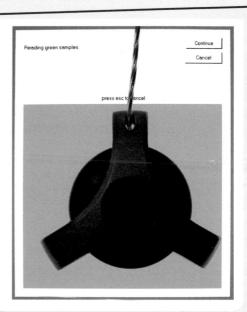

A Profile Is Created

The program then creates a profile for your monitor. This adjusts how the computer and monitor interpret color so that colors are predictable and consistent. This way, you know that there will be a better correlation between the colors on your monitor and the colors in your print.

Using Photo Printers with Elements

Today, almost all ink jet printers are capable of high-quality photo prints. However, a true photo printer can offer you the absolute best in print quality. Photo printers typically have more ink colors and finer ink dot sizes to create the best color and tonal gradations in a print. In addition, these printers have their software and hardware optimized for the print so that photos are the star of their performance. Many photographers have two printers, a small one for printing text quickly and a larger photo printer.

Using Photo Printers with Elements

SET ELEMENTS TO PRINT

You have to tell Elements how to send your photo to the printer so that colors are interpreted correctly.

- 1 Click File.
- 2 Click Print.

Note: A quick and easy keyboard command to remember for this is $Ctr / \mathcal{H} + P$.

CHECK YOUR PHOTO ORIENTATION AND SIZE

The Print dialog box opens.

- 3 Check to see if the photo is oriented wrong or the wrong size by looking at the preview.
- 4 Change the orientation using the buttons in the bottom-left corner.
- 5 You can make small changes in size in the Scaled Print Size area, but you should go back to Elements for large changes.

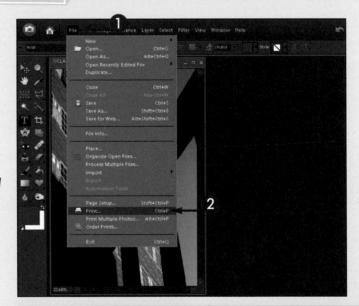

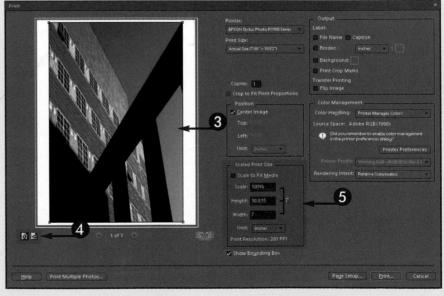

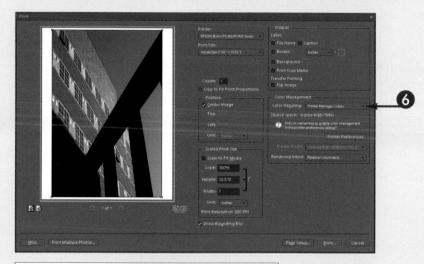

TELL ELEMENTS HOW TO DEAL WITH COLOR

6 In the Color Handling drop-down menu, choose **Printer Manages**Colors. With most printers, this gives you excellent results.

Some printers give better results if Elements manages color, another option in the Color Handling drop-down menu. Then you have to choose a printer profile that matches your paper type, as well as turn off color management in the printer driver software.

TRY A STAND-ALONE PRINTER

A really convenient way of getting quick prints is to use a compact, stand-alone printer. You simply take your memory card out of your camera and plug it into the printer. You can have the printer print all of your photos, a selected group, or even a proof sheet showing thumbnails of all of the images.

What if I do not have a photo printer? Can I still make good photo prints?

All printers on the market today are capable of good photo prints. You may not have some of the capabilities that a true photo printer has, and prints might not be quite as good, but your printer is probably capable of very good looking prints. The key is to choose the right paper and to set the printer driver correctly as described next in this chapter. Never use non-photo paper for prints — often the glossy papers work best for standard ink jet printers.

Set the Printer Driver Correctly

Once Elements is set to send your photo to the printer and you click Print, you go to your computer's operating system for printing. From there, you also access your printer's software controls, called the printer driver. The Windows and Mac operating systems display the printer

controls differently. Different types of printers also have different interfaces in Windows. Regardless, you have to access the interface where you can change settings like the paper you are using or whether you are making borderless prints.

Set the Printer Driver Correctly

TELL ELEMENTS TO PRINT

- 1 In the Elements Print dialog box, choose your print size.
- 2 Be sure that the print resolution is between 200 and 360 ppi. If it is not, you need to go back to Elements and resize your photo by clicking Image and choosing Resize.
- 3 Click Print.

OPEN YOUR PRINTER DRIVER

In Windows, the Print dialog box opens, and you need to follow another step to get to the printer driver. (This is not necessary in Mac OS dialogs.)

- 4 Choose a printer.
- **5** Click **Preferences** to open the driver.

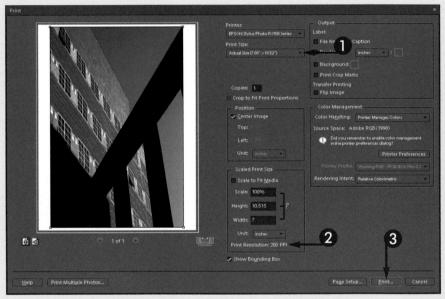

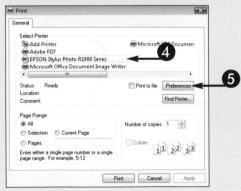

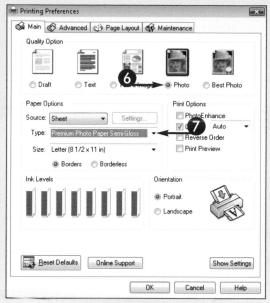

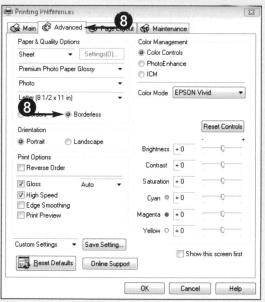

SET PAPER CHOICE AND QUALITY

This is a very important step. The printer has to know how to put ink down on the paper.

- 6 Choose **Photo** or **Best Photo**. You can test your results, but you will probably see little difference between these options.
- 7 Choose a paper in the **Type** drop-down menu, located in the Paper Options section.

TELL THE PRINTER WHETHER TO PRINT BORDERLESS

The printer does not automatically make a borderless print, even if you make a photo that is too large for the paper in Elements.

8 See if an Advanced tab includes the Borderless command. There is always a specific setting for this option in the printer driver, and you need to find and use it.

Simplify It

Printing inks can be expensive. How can I save money on inks? First, do not use the highest resolution your printer offers. That does little except use ink. Second, if the print is not looking good as it comes from the printer, press the Stop button on the printer to stop ink from being added to it. Third, if you have problems making a print look good, print a smaller version as you make corrections. Fourth, try a test strip as described later in the chapter. Finally, buying off-brand inks can be cheaper, too, but be sure they are photo inks designed to match the original inks.

Make the Right Paper Choice

To get the best photo print, you need to use the right photo paper. You are always safe with the manufacturers' papers for their printers, though you may find that some independent brands give you a look and a feel that you like. Be wary of cheap photo papers. These can be difficult to get the best colors on, and they usually do not have the best archival life. There are a wealth of choices in photo paper — pick what fits your needs.

Choose Paper for Its Surface

Photo papers have surface finishes that range from matte to glossy. Glossy papers have the richest colors and sharpest details, but they have shorter lives and reflect glare. Matte papers have long lives, do not reflect glare, and today, give very good, but different colors and sharper details than before. You can get other surface finishes in between these.

Thickness: 10 mil Weight: 250 g/m² Opacity: 97%

Select Paper for Its Weight

Paper has a weight. If your photo will be framed and behind glass, then weight has little bearing. But if you or anyone else are handling the prints, then they need some weight for durability. People also like the feel of a heavier print. Many fine-art photographers believe the heavier print is more appealing to clients.

Look for Paper with the Right Whiteness

Photo papers, like all printing papers, have different degrees of whiteness. If you are working with glossy or semi-gloss and similar papers, look for the whitest paper possible. With fine art papers, the degree of whiteness needed is very subjective, and many photographers believe that it affects how a viewer perceives the print.

Printing Paper Choice Is Very Subjective

There is no such thing as the best photo paper, only a best paper for you. Some photographers love glossy paper, for example, while others hate it. In addition, some subjects look better with one paper, while others look better with another, and so you have to try out some different papers to find what works best for you.

Make a Good Print

Ansel Adams had a lot to say about printing in his classic books about photography. Printing was a key part of the photo process for him. Getting a good print is really a craft. It is not simply a matter of pushing the right buttons,

because ultimately the best print is still very subjective. Good printing is a skill that is honed by making prints and learning what your printer can really do, as well as discovering the quirks and nuances of your digital system.

Make a Good Print

CAN YOU MATCH THE MONITOR?

Many people feel that if the print matches the monitor, they have a good print. There are several problems with this. First, a monitor displays colors in an entirely different way than a print. Second, people have quite a different psychological response to both media. Third, a print must stand on its own because few viewers ever see the monitor.

You do need a predictable workspace so that your monitor and print look close. However, take your print away from the monitor into good light and really look at it. Could it be better? Could it be lighter or darker? Do colors need to be adjusted? Is there a color cast? Go back to the computer and make adjustments based on this work print.

Simplify

CREATE A TEST STRIP FOR PRINTING

- Use the **Rectangular Marquee** selection tool () to select a thin strip through the important parts of your photo.
- 2 Copy this selection by pressing ctrl/#+c.
- 3 Click File.
- 4 Click New.
- 6 Click Image from Clipboard.
- This creates a new photo based on your selected strip. Print this test strip photo to keep print time shorter and costs down.

USE ADJUSTMENTS THAT YOU KNOW IN ELEMENTS

Use the adjustments you have learned in Elements to improve the look of your print. It can help to write on your work print what needs to be done. Often you need to use selections to affect the color or tone of very specific areas that look okay on the monitor, but do not look good in the print.

How many work prints do you need to make before you get a final print?

You might get a perfect print for your needs from the first print or it might take several. The concept of a work print is simply to give you the chance to evaluate your print as a print, not simply an automated process controlled by the computer. Ansel Adams always made work prints, sometimes many. For him, that took a long time because of the processing needed in the darkroom. But the digital photographer can try an adjustment and make a new print in minutes. This can also help you learn to make better prints in the future.

Add Text to a Print

There are many reasons for adding text to a print. You might want to include information about your subject or create a poster or flyer. Text is also useful for making a greeting card that you can print directly on your photo

printer. If you want to print a lot of text, such as in a newsletter, you need a design program. But for short bits of text on a print, Elements works very well.

Add Text to a Print

FIND THE TEXT TOOL

- 1 Click and hold the **Text** tool (**(III)**) to display four text tools that you can choose from.
- 2 Click a text tool. The horizontal and vertical tools are the easiest to use and the best place to start.

SET UP THE TEXT TOOL

The Text tool acts like any word processor. You have to tell it what font to use, the size, and so on.

3 Change these settings in the toolbar above the photo work area. You can choose the font, its weight, size, color, spacing, alignment, and so forth. You can also change these settings later.

Simplify It

CLICK AND TYPE

4 Click in the photo wherever you want the text, and start typing.

If necessary, edit the text using the controls in the toolbar at the top. First select the text by clicking and dragging over it.

MOVE YOUR TEXT

- **5** Move your text as you type by clicking outside of the text area until your cursor changes to a double-headed arrow. Then click and drag the text to where you want it.
- You can also move your text at any time by clicking the Move tool (at the top of the toolbox and clicking the layer with the text. Text is added to a photo as a layer so that you can move it easily.

When I am done with adding text, what should I do with that text layer?

One advantage of a text layer is that you can change it whenever you want. Just double-click on the text icon in the layers palette to highlight the text, and then type something new. You can save this text layer with your file if you save as a PSD file. If you want to save this file as a locked file with the text embedded into the image, you can flatten the image using the **Flatten** command in the **Layer** menu, then save as a TIFF file. If you save as a JPEG file, the layer is automatically merged into the photo.

2GB card, 10	autofocus (AF)
3/4 sidelight, 48	focus points, 16
90° sidelight, 49	focusing on most important part of subject, 96–97
	locking focus on subject, 16
A	starting early, 17
accessory flash, 131, 135–136	with telephoto lens, 117
ACDSee program	using continuous autofocus for action, 17
browsing and editing with, 148–149	AWB (auto white balance) inconsistency of, 73
creating quick slide shows, 156–157	in most light conditions, 73
organizing photos with, 150–151	overview, 72
overview, 145	problems with color of light using, 125
Quick Search function, 155	problems with sunrise and sunset, 72
renaming photos, 154–155	problems man same and a series
achromatic closeup lens, 114	
action	B
continuous autofocus for, 17	background
fast shutter speeds for, 82–83, 98	contrasting subject with, 27
monopods, 102	depth-of-field in, 98 distractions in, 21, 26
Adams, Ansel, 190, 192	front light on, 46
Adjust Color Curves dialog box, Photoshop Elements, 171, 175	need for depth-of-field, 98
Adjust Color for Skin Tone dialog box, Photoshop Elements, 173	placing, 27
Adjust Sharpness dialog box, Photoshop Elements, 181	simplifying, 26
Adjust Smart Fix, Photoshop Elements, 171 adjustment layer, Photoshop Elements, 199	and telephoto lenses, 109
advanced setting, ACDSee slide show, 157	using flash when bright, 54
AEB (auto exposure bracketing), 69	backing up photo, 144–145
AF (autofocus)	backlight
focus points, 16	dramatic photos, 50
focusing on most important part of subject, 96–97	exposure, 51
locking focus on subject, 16	separating parts of photo with, 50
starting early, 17	watching out for flare, 51
with telephoto lens, 117	backup software, 145
using continuous autofocus for action, 17	bad timing in photo, 153
album, Photoshop Elements, 147	balancing subject, 33
angle of movement, 83	ballhead, tripod, 101
aperture. See also f-stop	Basic tab, Slide Show Properties dialog box, 156
choosing lenses based on, 119	Batch Rename dialog box, ACDSee program, 154
choosing program mode, 14	battery, 5
f-stops, 78	beanbag
Aperture-Priority mode	for long exposures, 59
choosing program mode, 14	as portable support, 102 with screw, 128
choosing shutter speed and f-stop, 81	big-range lens, 119
setting small f-stop with, 87	black slider, Photoshop Elements Levels, 169
artifact, 197	black-and-white photo
artificial light	adjusting contrast of, 175
contrast, 123 light color, 122	converting colors into contrasting tones of gray, 17
noise, 123	converting to, 175
sharpness, 122	removing color, 174
Aspect Ratio dropdown menu, Photoshop Elements toolbar, 165	blending selection edge, 187
Auto Color Correction, Photoshop Elements, 172	blown-out highlight, 66-67
Auto Contrast, Photoshop Elements, 168	blue effect, 77
auto controls, Photoshop Elements, 170, 172	blurry photo
auto exposure bracketing (AEB), 69	avoiding with tripods, 59
Auto Levels, Photoshop Elements, 170	from camera movement, 12, 94
auto power down, 5	deleting, 152
Auto Rotate setting, 5	printing, 202
Auto Sharpen, Photoshop Elements, 180	with slow shutter speeds, 82, 84-85, 87
auto slide show, ACDSee, 156	when shooting in artificial light, 122
Auto Smart Fix, Photoshop Elements, 168, 170	border, photo, 209
auto white balance (AWB)	bouncing flash, 136–137
inconsistency of, 73	bracing camera for sharpness, 128–129
in most light conditions, 73	breathing, 127
overview, 72	bright spot
problems with color of light using, 125	in backgrounds, 21, 26–27 causing hot spots in photo, 44
problems with sunrise and sunset, 72	brightness
autoexposure, 81	adjusting with Photoshop Elements, 169
	consistency of LCD, 6

controlling with shutter speed and f-stop, 80	simplicity, 23
creating with flash, 54	taking step closer, 23
heightening in Photoshop Elements, 170–171	watching space around, 22
and ISO settings, 90	closeup lens, 114
limiting red-eye, 133	close-up shot
measuring with meter, 62	checking where camera focuses, 97
meter reaction to, 63	creating bold center in, 30
and shadows, 41–42 of shadows due to overexposure, 67	focusing on most important part of subject, 96
underexposure due to, 64	lenses for, 114–115
Brightness/Contrast dialog box, Photoshop Elements	midday light for, 56
darkening edges for traditional look, 195	using zoom for, 110
darkening specific areas of photo, 191	wide angles for portraits, 117 Cloudy white balance setting, 75, 77
making dark photos brighter, 170	color
browsing photos with ACDSee, 148–149	of artificial light, 122
brush size for cloning in Photoshop Elements, 197	boosting with flash, 54
Burn tool, Photoshop Elements, 191, 193	brightening, 189
buying lens	calibrating monitors, 204–205
being wary of other photographers' advice, 118	contrasting subject with, 27
care with big-range lenses, 119	converting into contrasting tones of gray, 175
expensive is not always better, 119	correcting in Photoshop Elements, 168, 172–173
look at limitations in picture taking, 118	correcting with white balance, 124–125
	increasing saturation, 188–189
C	and ISO settings, 90–91
	of light and artificial light, 122
calibrating monitor, 204–205	lost due to underexposure, 64
camera. See also LCD; lens; mode; setup; shutter button; shutter speed	from low front light, 47
aperture, 14, 78, 119 bracing for sharpness, 128–129	neutral, 70, 72
control of flash exposure by, 130	problems from dark exposures, 203
downloading from, 140	with telephoto lenses, 109
handholding technique, 126	washed out due to overexposure, 66
holding vertically, 36	when printing, 207
icons, 8	in wide angle portrait shots, 116
locking response with defined white balance setting, 74	color cast
long exposures, 59	creating mood with, 124
manual, 8, 125	fixing gray photos, 168
meter, 62–63	removing in Photoshop Elements, 172–173
minimizing movement of for sharpness, 94–95	white balance, 71–72
operation menu section, 8	Color Curves, Photoshop Elements, 171
sensitivity of and ISO settings, 90	color filter, 70
sensor, 8, 64	Color Handling drop-down menu, Photoshop Elements, 207
sharpness of focus, 96–97	Color Variations dialog box, Photoshop Elements, 173
sleep time, 5	CompactFlash card, 10
supporting, 12, 59, 102–103	Compare Images area, ACDSee program, 149
tilting, 33	compensation, exposure, 68
tripods, 100–101	composition background, 26–27
video, 71	centered subjects, 30–31
viewfinder, 6–7	foreground, 24–25
capacity, memory card, 10	getting close to subject, 22–23
car, shooting from, 13	overview, 18–19
carbon fiber tripod, 100	placing heads, 32–33
cast, color. See color cast	rule of thirds, 28–29
category, ACDSee, 151	shooting verticals and horizontals, 36–37
ceiling, tilting flash to, 136	simplicity, 20–21
centered subject	tightening with zoom lens, 110
balancing night and day, 31	watching edges, 34–35
centering close portrait left and right, 33	compression, quality, 9
creating bold center, 30 finding balanced composition, 30	computer
	calibrating monitor, 204–205
looking for patterns, 31 chroma, 64	importing photos to, 140–141
clarity, 52	organizing photos on hard drive, 142-143
clicking and dragging photo, 143–144	concentric pattern, 31
Clone Stamp tool, Photoshop Elements, 196	condition, matching defined white balance setting to, 75
cloning in Photoshop Elements, 196–197	consistency of defined white balance setting, 74
close focusing setting, 114	continuous autofocus, 17
closeness to subject	continuous-shooting setting
experimenting with zoom, 23	for indoor and night shots, 127
narrow focus due to, 96	overview, 69

contrast	depth-of-field
adjusting in black-and-white photo, 175	increasing with small f-stops, 86–87
artificial light, 123	needed by foreground and background, 98
in black and white photos, 175	zooming out to increase, 110
from flash, 134	detail
with shadows, 41–42	on edge of photo, 34
of sharpness, 99	lightening dark, 192
in spotlights, 53	using telephoto lens for, 109
of subject with background, 27	diffuser, flash, 135
converting	digital camera. See camera
to black-and-white photo, 175	Digital Images folder, 142–143
colors into contrasting tones of gray, 175	digital SLR. See also camera
correcting color in Photoshop Elements, 172–173	accessory flashes, 131
correcting exposure	auto exposure bracketing, 69
exposure compensation, 68	backgrounds, 26
locking exposure, 69	close-focusing settings, 114
trying AEB, 69	closeup accessory lenses, 114
using LCD, 68	creating depth-of-field with, 89
creativity	extension tubes, 115
blurring action with slow shutter speed, 85	handholding positions, 12, 95, 126
using white balance settings, 76–77	lenses for, 104, 118
crooked horizon	memory cards for, 10
fixing photos in wrong orientation, 167	modes of, 14
lining up horizons with straight line, 166–167	RAW files, 9
rotating crop box, 166	using with separate flashes, 55
using custom rotation for precise control, 167	wide-angle lenses for, 112
cropping	dimension
dragging box around subject, 164 experimenting with, 165	creating, 24 in sidelighting, 48
	direction of shadow, 137
finding Crop tool, 164 head to show face, 32	
to specific size, 165	distance, compressing, 109 distraction in photo
subject at edge of photo, 35	avoiding, 21
cross shadow, 43	background, 26
curving line, 35	scanning edge for, 34
custom rotation, Photoshop Elements, 167	shadows, 43
custom white balance, 125	Dodge tool, Photoshop Elements, 193
	double flash, 130
D	downloading
darkening color, 66	from camera, 140
darkening specific area of photo, 190–191	from memory card, 11
darkness	from memory card reader, 141
brightening in Photoshop Elements, 170–171	speed of, 11
color problems, 203	dragging photo, 143
meter reaction to, 63	dramatic photo
noise from, 203	backlight, 50
overexposure, 67	from low front light, 46
underexposure, 65	sidelight, 48
date, organization by in Photoshop Elements, 146	spotlights, 53
day, time of	drive backing up photos on second, 144–145
after sun has set, 57	
early light is great landscape light, 56	importing photos to, 140
late light, 57	organizing photos on hard, 142–143
midday light for close-ups, 56	driver, printer, 208–209 dull day photo, 54
daylight white balance settings, 77	duli day prioto, 34
dedicated flash cord, 135	
defined white balance setting	E CONTRACTOR OF THE CONTRACTOR
consistency of, 74	early light, 56
locking camera's response with, 74	edge of photo
matching to conditions, 75	creating photo with all detail on, 34
using creatively, 76–77	darkening, 195
warming up photos with, 75	deliberately cropping subject at, 35
deleting photo, 152–153	leading viewer in from, 35 scanning for distractions, 34
depth backlight, 50	Edit option, Photoshop Elements, 160
using foreground for, 24	editing. See also Photoshop Elements
3 10103.00110 101, = 1	with ACDSee, 148–149
	photo, 152-153
	electronic viewfinder (EVF), 6

lements. See Photoshop Elements lements Print dialog box, Photoshop Elements, 208	bouncing for more natural light, 136–137 dealing with red-eye, 132–133
Illipse/Circle selection tool, Photoshop Elements, 184 Illiptical Marquee tool, Photoshop Elements, 194	in-camera, 131 night flash setting, 134
e-mail, sizing picture for, 178–179	off-camera, 55, 135, 137
enlarging image file, 177 environment, zooming out to include, 110	overview, 120–121, 130–131 using when light is harsh, 54–55
erasing photo, 152–153	flash-dedicated extension cord, 136
evening photo, 57	Flatten command, Photoshop Elements, 199, 215
event, creating folder for, 143 EVF (electronic viewfinder), 6	flower icon, 114 focal length. See <i>also</i> lens
expense of lens, 119	choosing for different subjects, 112–113
exposure	overview, 104
adjusting with Manual mode, 15	and portraits, 116–117
backlight, 51 control of flash by camera, 130	telephoto lens, 108 focus. See <i>al</i> so autofocus
controlling with shutter speed and f-stop, 80–81	distance of and exposure, 62
correcting problems, 68–69	on most important part of subject, 96–97
ISO setting affecting choices, 90–91 locking, 69	of portrait with telephoto lens, 117
movement during, 12	problems in photos, 152 on subject, zooming in to, 111
for moving lights, 59	focus lock button, 16
overexposure, 66–67	focus point, 16
overview, 60–61 problems from dark, 203	folder for photos, 142–143
problems in photos, 152	foreground front light on, 46
spotlight, 53	getting close and shooting through, 25
supporting camera for long, 59	looking for frame, 24
underexposure, 64–65 washed-out, in prints, 202	making bolder with wide angle lens, 107 need for depth-of-field, 98
what camera meter does, 62–63	using for depth, 24
exposure compensation, 68	using wide-angle view and tilting down, 25
exposure mode choices, 14	framing. See also composition
extension tube, 115 external hard drive, 144–145	with foreground, 24 getting closer to subject, 23
ye	locking focus on subject, 16
focusing on, 117	overview, 18
sharpness of, 97 yedropper tool, Photoshop Elements, 189	using viewfinder or LCD, 6–7 front light
yedropper tool, Photoshop Elements, 103	boring photos from, 46
	colorful photos, 47
ace	dramatic photos, 46
cropping head to show, 32	for people, 47 f-stop
isolating with telephoto lens, 116 ast action, 98	big-range lenses, 119
ast shutter speed	choosing for sharpness, 98-99
angle of movement, 83	controlling exposure with, 80–81
for fast action, 98	creating shallow depth-of-field with large, 88–89 increasing depth-of-field with small, 86–87
movement is about time, 82 speed of movement, 82	overview, 78–79
timing of shutter affects movement, 83	program mode, 14
eather Selection dialog box, Photoshop Elements	
blending selection edge, 187	G
darkening specific area, 190 feathering dark edges, 194	Get Photos dialog box, Photoshop Elements, 146 glossy paper, 210–211
lightening specific area, 192	gorillapod, 103
le size, 179	gray, converting color into, 175
lle type finding settings, 8	gray photo, fixing, 168–169
JPEG, 9, 163, 179	greeting card, 214 group photograph, 33
PSD, 163, 215	grouping photos in Photoshop Elements, 147
RAW, 9–10	
TIFF, 163, 199, 215 llename, 154–155	H
lter, color, 70	handholding camera
Itering in ACDSee, 151	minimizing camera movement, 94–95 shutter speed technique, 126
are, 51	vertically, 36
ash accessory, 131	
avoiding shadow problems, 134–135	

hard drive	K
backing up photos on external, 145	keyword tag, Photoshop Elements, 147
importing photos to, 140 organizing photos on, 142–143	
hard-edged shadow, 45, 49	
harsh light, 44, 134	landscape
head placement	depth-of-field, 87, 98
centering close portrait left and right, 33	early light for, 56 wide angle lens for wide, 112
cropping head to show face, 32	Landscape mode, 15
keeping back row of heads close to top, 33 keeping headroom tight, 32	large f-stop, 88–89
headroom, 32	large resolution, 8
high ISO setting, 91	Lasso selection tool, Photoshop Elements, 184
highlight, blown-out, 66–67	late light, 57 layer, Photoshop Elements, 198–199
histogram, 169	LCD
holding camera minimizing camera movement, 94–95	Auto Rotate, 5
shutter speed technique, 126	camera sleep time, 5
vertically, 36	for close shooting, 7
horizon	correcting exposure with, 68
balancing night and day, 31	review time, 4 using inside, 6
fixing photos in wrong orientation, 167	using to review, 21
lining up with straight line, 166–167 rotating crop box, 166	leading viewer in from edge of photo, 35
rule of thirds, 28	lens. See also telephoto lens
tilting down wide-angle lens, 25	achromatic closeup, 114
using custom rotation for precise control, 167	buying, 118–119
horizontal photo, 37, 157	choosing focal lengths for different subjects, 112–113 closeup, 114–115
horizontal third, 28	flash away from to reduce red-eye, 132
hot spot, 44 Hue/Saturation dialog box, Photoshop Elements, 188–189	focal length and portraits, 116–117
True/saturation dialog box, Thotoshop Elements, 100-109	f-stop, 78
	macro, 115
icon, camera, 8	overview, 104–105
image. See photo	wide angle, 25, 106–107, 112–113, 116–117, 126 zoom, 110–111
Image Size dialog box, Photoshop Elements, 176–178	lens shade, 51
image type. See file type	Levels, Photoshop Elements, 169, 193
importing photos to computer, 140–141	light. See also indoor light; night photo
in-camera flash, 131. See also flash	artificial, 122–123
inconsistency of auto white balance, 73 indoor light	auto white balance, 73
appropriate shutter speed technique, 126–127	backlight, 50–51 bouncing flash for more natural, 136–137
artificial light, 122–123	changes in due to time of day, 56–57
avoiding flash shadow problems, 134–135	controlling with f-stops, 80
bouncing flash for more natural light, 136–137	controlling with shutter speed, 81
bracing camera for sharpness, 128–129	locating, 40
correcting color with white balance, 124–125 dealing with red-eye, 132–133	low front light, 46–47
overview, 120–121	measured by camera meters, 62 noticing highlights and shadows, 41
understanding how flash works, 130–131	overview, 38–39
indoors, shooting with wide angle lens, 106	shadows, 42–43
ink, printing, 209	sidelight, 48–49
intersection in photo, 29 inverting selection in Photoshop Elements, 195	spotlight, 52–53
ISO setting	using flash for harsh, 54–55
affecting exposure choices, 90–91	using ISO settings, 90 using LCD review, 41
changing for night photo, 58	using viewfinders for, 6
noise from, 123	watching in subject and background, 40
isolating faces with telephoto lens, 116	what to avoid, 44-45
	light color, 122
	lightening specific areas of photo, 192–193
JPEG file	line concentric, 31
with high quality, 9	curving, 35
other formats, 163	locking
saving photos as, 179 JPEG Options dialog box, Photoshop Elements, 179	camera's response with defined white balance setting,
Ji La Options dialog box, Photoshop Elements, 179	exposure, 69
	focus, 16, 97

74

low front light	N
boring photos from, 46	
colorful photos, 47	name, photo, 145, 154–155
dramatic photos, 46	narrow focus, 96
for people, 47	natural light, 136–137
low ISO setting, 90	neutral tone, 70, 72
ion iso setting, so	night flash setting, 134
	night photo
M	appropriate shutter speed technique, 126–127
macro lens, 115	artificial light, 122–123
Magic Wand tool, Photoshop Elements, 185, 187	avoiding flash shadow problems, 134–135
Magnetic Lasso tool, Photoshop Elements, 185	bouncing flash for more natural light, 136–137
magnifying photo with ACDSee, 148–149	bracing camera for sharpness, 128–129
manual	changing ISO, 58
checking icons in, 8	correcting color with white balance, 124–125
custom white balance setting instructions, 125	daylight white balance settings at, 77
Manual exposure setting, 55	dealing with red-eye, 132–133
Manual mode, 15	looking for moving lights, 59
matte paper, 210	overview, 58, 120–121
medium resolution, 8	supporting camera for long exposures, 59
megapixel, 8	understanding how flash works, 130–131
memory buffer, 11	noise
memory card	artificial light, 123
capacity of, 10	in dark exposures, 203
downloading from, 11	increase in due to underexposure, 65
speed of, 11	and ISO setting, 90–91
types of, 10	number, f-stop, 86, 88
memory card reader, 11, 141	
menu	0
right-click, 147	off-camera flash
setup, 4–5	
meter	avoiding shadows with, 135
bright scenes, 63	bouncing, 137
dark scenes, 63	to deal with harsh light, 55
exposure based on interpretations, 62	Open dialog box, Photoshop Elements, 160
measuring brightness, 62	optical viewfinder, 6–7
mice button, 147	Organize module, Photoshop Elements, 146–147
midday light	Organize panel, ACDSee program, 151
for close-ups, 56	organizing
difficulties with, 44	with ACDSee, 150–151
front light, 46	on hard drive, 142–143
mode	using Photoshop Elements, 146–147
Aperture-Priority, 14	orientation, photo, 167, 206
exposure mode choices, 14	original photo, protecting, 162
Landscape, 15	overexposure
Manual, 15	dark scenes, 63, 67
overview, 15	eliminating photos with, 152
Portrait, 15	lost highlights, 66
Program, 14	in prints, 202
Shutter Speed-Priority, 14, 81	too bright shadows, 67
Sports, 15	washed out color, 66
monitor	
calibrating, 204–205	P
	palette, Photoshop Elements, 161, 163
comparing images on, 149	Palette Bin, Photoshop Elements, 161
comparing print to, 212	pan-and-tilt head, tripod, 101
monopod, 102	panning camera with slow shutter speeds, 99
mood, creating with white balance, 124	paper, photo, 207, 209–211
morning light, 56 mouse button, 147	pattern in photo, 31, 43
Move tool, Photoshop Elements, 215	photo. See also blurry photo; close-up shot; composition; cropping; edge of
	photo; foreground; night photo; Photoshop Elements; portrait; printing;
movement	reviewing image; vertical photo
blurry photos caused by, 12	backing up on second drive, 144–145
during exposure, 107	bad timing in, 153
minimizing for sharpness, 94–95	border, 209
panning with, 99 stopping with fast shutter speed, 82–83	browsing and editing with ACDSee, 148–149
	camera movement causing blurry, 12
with telephoto lenses, 108 using continuous autofocus for, 17	checking size before printing, 206
moving light, 59	clicking and dragging, 143–144
moving light, Ja	- 1 - 1 - 1 - 1 - 1 - 1 - 1 - 1 - 1 - 1

creating quick slide shows with ACDSee, 156–157	portrait
distractions in, 21, 26, 34, 43	creating shallow depth-of-field for, 88
dividing into horizontal thirds, 28 dividing into vertical thirds, 28	focal length and, 116–117 importance of sharpness of eyes in, 97
downloading, 11, 140–141	low front light for, 47
dramatic, 46, 48, 50, 53	placing heads, 32–33
editing, 152–153	telephoto lens for, 112, 116
fixing crooked horizon, 166–167	using zoom for, 116
fixing gray, 168–169	Portrait mode, 15
folder for, 142–143	position, shooting
group, 33	bracing camera for sharpness, 128–129
horizontal, 37, 157	minimizing camera movement, 94–95 shutter speed technique, 126
importing to computer, 140–141	for verticals and horizontals, 36–37
leading viewer in from edge of, 35	
organizing on hard drive, 142–143 organizing with ACDSee, 150–151	poster, 214 pre-flash, 130
overview, 138–139	preparing camera
printing, 176	autofocus, 16–17
	choosing between viewfinder and LCD, 6–7
processing, 65–66, 133 rating, 146, 150	holding camera for sharpness, 12–13
	LCD, 4–5
renaming, 145, 154–155 resizing, 177–178	memory card, 10–11
resolution, 8	overview, 2–3
	program mode, 14–15
saving as JPEG file, 179	resolution and file type, 8–9
scenic, 15, 47 separating parts of with backlight, 50	pressing shutter, 13, 95
sizing for e-mail, 178–179	Print dialog box
	Photoshop Elements, 206
sizing for printing, 176–177	Windows, 208
sorting, 146, 150	
straightening, 166 travel, 113	printing adding text to print, 214–215
warming up, 75, 172–173	calibrating monitor, 204–205
hotoshop (PSD) files, 163, 215	choosing paper, 210–211
hotoshop Elements	making good prints, 212–213
adding text to print, 214–215	overview, 200–201
black-and-white photos, 174–175	setting printer driver correctly, 208–209
cloning effectively, 196–197	sizing picture for in Photoshop Elements, 176–177
correcting color, 172–173	starting with good photo, 202–203
cropping photos, 164–165	using photo printers with Elements, 206–207
darkening edges for traditional look, 194–195	printing ink, 209
darkening specific areas of photo, 190–191	Printing Preferences dialog box, Windows, 208–209
fixing crooked horizons, 166–167	processing
fixing gray photos, 168–169	brightening, 65
increasing color saturation, 188–189	darkening, 66
layers, 198–199	red-eye reduction, 133
lightening specific areas of photo, 192–193	profile, monitor calibration, 205
making dark photos brighter, 170–171	program. See also ACDSee program; Photoshop Elements
modifying selections, 186–187	backup, 145
organizing photos with, 146–147	calibrating monitor, 205
overview, 145, 158–159, 182–183	program autoexposure, 81
safety features, 162–163	program mode
setup of, 160–161	Aperture-Priority, 14
sharpening image, 180–181	exposure mode choices, 14
sizing photos for e-mail, 178–179	Landscape, 15
sizing picture for printing, 176–177	Manual, 15
telling to print, 208	overview, 15
using adjustments to make good prints, 213	Portrait, 15
using photo printers with, 206–207	Program, 14
using selections to isolate adjustments, 184–185	Shutter Speed-Priority, 14, 81
icture. See photo	Sports, 15
ictures folder, 142	PSD (Photoshop) files, 163, 215
layback button, reviewing images with, 4	puck, calibration, 204
od beanbag, The, 128	
oint, setting clone from in Photoshop Elements, 196	0
olygonal Lasso tool, Photoshop Elements	Q
darkening edges, 194	quality of color, 64
modifying selections with, 187	compression, 9
overview, 184	picture, 8
	Quick Search function, ACDSee, 155
	A area search tarrens. I he seed 133

R	holding camera for sharpness, 12–13	
range, zoom, 111	LCD, 4–5	
rating photo	memory card, 10–11	
in ACDSee, 150	overview, 2–3 program mode, 14–15	
in Photoshop Elements, 146	resolution and file type, 8–9	
RAW file, 9–10 Rectangle/Square selection tool, Photoshop Elements, 184	setup menu, 4–5	
Rectangular Marquee selection tool, Photoshop Elements, 213	shade, lens, 51	
red-eye, 132–133	Shade setting, 75	
Remove Color Cast dialog box, Photoshop Elements, 172	shadow	
removing color from photo, 174	avoiding flash problems, 134–135	
renaming photo, 145, 154–155	avoiding inappropriate, 45	
Resample Image option, Photoshop Image Size dialog box, 177	in backlight, 50	
Reset tool, Photoshop Elements, 165	distracting, 43	
resizing image, 177–178	in front light, 46	
resolution	as important part of light, 42	
finding settings, 8	making interesting photographs, 43 making subject stand out, 42	
printing, 176	from midday sun, 44	
using megapixels, 8	off-camera bounce changing direction of, 137	
reviewing image for bright spots, 44	overexposure, 67	
for contrast in night shots, 123	sidelight, 48–49	
edges, 34	Shadows/Highlights dialog box, Photoshop Elements, 171	
exposure, 51, 68	shallow depth-of-field, 88–89	
with LCD, 4	shape selection, Photoshop Elements, 184	
subject size, 22	sharpness	
right-click menu, 147	artificial light, 122	
Rotate Canvas dialog box, Photoshop Elements, 167	bracing camera for, 128–129	
rotating crop box, 166	depth-of-field, 86	
rotation, Photoshop Elements custom, 167	enhancing in Photoshop Elements, 180–181 focusing on most important part of subject, 96–97	
row of heads in photo, 33	f-stop or shutter speed for, 98–99	
rule of thirds dividing photo into horizontal thirds, 28	holding camera for, 12–13	
dividing photo into vertical thirds, 28	macro lens for, 115	
as guideline, 29	maximizing with tripod, 100–101	
using intersections, 29	minimizing camera movement, 94–95	
	other camera supports, 102–103	
S	overview, 92–93	
saturation, 188–189	shallow depth-of-field, 88	
Save As dialog box, Photoshop Elements, 162	shooting position	
Save N Sync program, 145	bracing camera for sharpness, 128–129 minimizing camera movement, 94–95	
saving	shutter speed technique, 126	
layers in Photoshop Elements, 199	for verticals and horizontals, 36–37	
photos as JPEG files, 179	shooting through foreground, 25	
work in Photoshop Elements, 163	shrinking image, 177	
scene	shutter button	
changes in due to flash use, 55	focusing with, 17	
making more interesting with spotlight, 53	locking exposure with, 69	
shooting big with wide angle lens, 106	reaching in vertical positions, 36	
scenic picture, 15, 47. See also landscape screw, beanbag with, 128	squeezing, 13, 95	
SD card, 10	shutter speed	
searching for photo in Photoshop Elements, 147	blurring action with slow, 84–85	
selection, Photoshop Elements	choosing for sharpness, 98–99	
darkening edges for traditional look, 194–195	controlling exposure with, 80–81 exposure mode choices, 14	
darkening specific areas of photo, 190	high ISO setting, 91	
lightening specific areas of photo, 192	increasing depth-of-field with small f-stops, 87	
modifying, 186–187	overview, 78–79	
using to isolate adjustments, 184–185	stopping action with fast, 82–83	
using to limit color change, 189	techniques for indoor and night light, 126–127	
Selection Brush tool, Photoshop Elements, 185	telephoto lens, 108	
self-timer, 129 sensitivity, 90	wide angle lens, 107	
sensor, 8, 64	Shutter Speed-Priority mode, 14, 81	
separating parts of photo with backlight, 50	sidelight	
setting of portraits, 116	making textures come alive with, 48 shadows from, 49	
setup	using 3/4 sidelight for form plus texture, 48	
autofocus, 16–17	using 90° sidelight for strong texture, 49	
choosing between viewfinder and LCD, 6–7	, , , , , , , , , , , , , , , , , , , ,	

simplicity	subfolder, 142–143
avoiding distractions, 21	subject
background, 26	avoiding light that is away from, 45
closeness to subject, 23	balancing night and day, 31
deciding what subject really is, 20	brightening with flash on dull day, 54
drawing attention to subject, 20	centering left and right, 33
using LCD review, 21	choosing focal length for different, 112–11
size, photo checking before printing, 206	close up photographs of, 56 contrasting with background, 27
cropping to specific, 165	correcting color with white balance, 124
sizing picture	creating bold center, 30
for e-mail, 178–179	deciding on, 20
for printing, 176–177	deliberately cropping at edge of photo, 35
skin color	distracting backgrounds, 26
adjusting in Photoshop Elements, 173	drawing attention to, 20
correcting with white balance, 124	experimenting with zoom, 23
sleep time, 5	finding balanced composition, 30
slide show, ACDSee, 156–157	focusing on most important part of, 96-97
Slide Show Properties dialog box, ACDSee program, 156	framing, 24
slow shutter speed	horizontal photo of vertical, 37
blurring action with, 84–85	isolating with telephoto lens, 108
panning camera with, 99	lighting of, 40, 45
and wide angle lens, 107	locking focus on, 16
SLR camera, digital. See also camera	looking for patterns, 31
accessory flashes, 131	low front light for, 47
auto exposure bracketing, 69	positioning of, 28–29
backgrounds, 26	shadows on, 42, 45
close-focusing settings, 114	shallow depth-of-field, 89
closeup accessory lenses, 114	simplicity, 23
creating depth-of-field with, 89	spotlight on, 52
extension tubes, 115	taking step closer, 23
handholding positions, 12, 95, 126	using flash to brighten dark, 54
lenses for, 104, 118	vertical photo of horizontal, 37
memory cards for, 10	vertical photo of vertical, 36
modes of, 14	watching space around, 22
RAW files, 9	zooming in to focus on, 111
using with separate flashes, 55	sunlight, 44, 47
wide-angle lenses for, 112 small f-stop, 86–87	Sunlight setting, 75–77 sunrise, 72
small resolution, 8	sunset
softening flash, 135	balancing night and day, 31
softening foreground, 25	cloudy white balance setting for, 77
software. See also ACDSee program; Photoshop Elements	problems with auto white balance, 72
backup, 145	shooting after, 57
calibrating monitor, 205	Superfine compression, 9
Sort By feature, ACDSee, 150	supporting camera
sorting	for long exposures, 59
in ACDSee, 150	for sharpness, 12
in Photoshop Elements, 146	types of supports, 102–103
space around subject, 22	surface, paper, 210
specular light, 134	
speed	T
memory card, 11	table-top tripod, 103
of movement and fast shutter speed, 82	
Sponge tool, Photoshop Elements, 191	telephoto lens auto white balance, 73
sports action, 85, 102	buying, 118
Sports mode, 15	compressing distances with, 109
spotlight	contrasting sharpness, 99
clearly showing subject, 52	creating shallow depth-of-field, 89
exposure, 53	isolating faces with, 116
making scene more interesting, 53	isolating subject with, 108
theatrical light, 52	for people, 112
squeezing shutter, 13, 95	portrait focus with, 117
stand-alone printer, 207	shooting through foreground, 25
standard naming system, ACDSee, 155	shutter speed, 108, 126
star rating, 146	using for details, 109
stopping action with fast shutter speed, 82–83	wildlife shots, 113
straightening photo, 166 sturdiness of tripod, 100	test strip for printing, 213

text	V
adding to ACDSee slide show, 157	vertical photo
adding to prints, 214–215	Auto Rotate setting, 5
Text tab, Slide Show Properties dialog box, 157	experimenting with holding camera vertically, 36
Text tool, Photoshop Elements, 214–215	of horizontal subjects, 37
texture	in slideshow, 157
3/4 sidelight for form plus, 48	of vertical subjects, 36
90° sidelight for strong, 49	vertical thirds, 28
in early light, 56	
from sidelight, 48	video camera, 71
with telephoto lenses, 109	viewer, leading in from edge of photo, 35 viewfinder
in wide angle portrait shots, 116	
heatrical light, 52	using for moving subjects, 7
humbnail area, ACDSee, 148–149	using in bright light, 6
TIFF file	viewing angle, monitor, 149
saving images as, 163	
saving layers to, 199, 215	W
ilting camera, 33	wall, turning flash to, 136
ilting flash to ceiling, 136	warm light, 57
Fime Machine program, 145	warming up photo
ime of day	with defined white balance setting, 75
after sun has set, 57	in Photoshop Elements, 172–173
early light for landscapes, 56	washed-out exposure, 66, 202
late light, 57	water, shooting with slow shutter speed, 85
midday light for close-ups, 56	Web site photograph, 8
	weight, paper, 210
ACDS on slide show 156	white balance
ACDSee slide show, 156	correcting color with, 124–125
autofocus, 17	defined settings, 74–75
of movement and fast shutter speed, 82–83	overview, 70–71
in photo, 153	using settings creatively, 76–77
onal contrast, 42	when to use auto white balance, 72–73
oolbar, Photoshop Elements, 160	white card, 125
oolbox, Photoshop Elements, 160	white clid, 125 white slider, Photoshop Elements Levels, 169
ransition, ACDSee slide show, 156	
ravel photo, 113	whiteness, paper, 211 wide angle lens
ripod	capturing wide landscapes, 112
ballheads, 101	indoors, 106
bracing camera for sharpness, 129	making foreground bolder, 107
carbon-fiber, 100	portraits with, 116–117
for night shots, 58–59, 128	shooting big scenes, 106
pan-and-tilt heads, 101	
for slow shutter speed photos, 85	shooting foreground with and tilting down, 25
for small f-stops, 86	shutter speed for indoor and night shots, 126
sturdiness of, 100	and slower shutter speeds, 107
ube, extension, 115	for travel photos, 113
ungsten white balance setting, 75, 77	wide aperture, 88
	wildlife photograph, 108, 113
	workprint 213
inderexposure	workprint, 213
bright lights, 63–64	
eliminating background with, 55	
eliminating photos with, 152	zoom
hard to separate dark tones, 65	AWB in, 73
increased noise, 65	closeness to subject, 23
lost color from, 64	depth-of_field in, 89
from low light, 123	WB in, 74
Indo command, Photoshop Elements, 162	for wildlife pictures, 113
Indo History palette, Photoshop Elements	zoom lens
editing dark edges, 195	experimenting with zoom range, 111
overview, 161	tightening composition with, 110
use of, 163	zooming in to focus on subject, 111
Insharp Mask dialog box, Photoshop Elements, 180–181	zooming out to include environment, 110
ISB cord, 140	Zoom Magnifier tool, Photoshop Elements, 180, 196
130 (0) (1)	

There's a Visual book for every learning level...

Simplified

The place to start if you're new to computers. Full color.

- Computers
- Creating Web Pages
- Mac OS

- Office
- Windows

Teach Yourself VISUA

Get beginning to intermediate-level training in a variety of topics. Full color.

- Access
- Bridge
- Chess
- Computers
- Crocheting
- Digital Photography
- Dog training
- Dreamweaver
- Excel
- Flash

- Golf
- Guitar
- Handspinning
- HTML
- · Jewelry Making & Beading
- Knitting
- Mac OS
- Office
- Photoshop
- Photoshop Elements

- · Piano
- Poker
- PowerPoint
- Quilting
- Scrapbooking
- Sewing
- Windows
- Wireless Networking
- Word

O Simplified Tips & Tri

Tips and techniques to take your skills beyond the basics. Full color.

- Digital Photography
- eBay
- Excel
- Google

- Internet
- Mac OS
- Office
- Photoshop

- Photoshop Elements
- PowerPoint
- Windows

...all designed for visual learners—just like you!

Master VISUA

Your complete visual reference. Two-color interior.

- · 3ds Max
- Creating Web Pages
- Dreamweaver and Flash
- Excel VBA Programming
- iPod and iTunes
- · Mac OS
- Office
- Optimizing PC Performance
- Photoshop Elements
- OuickBooks
- Ouicken
- Windows
- · Windows Mobile
- · Windows Server

Visual Blueprint

Where to go for professional-level programming instruction. Two-color interior.

- Aiax
- ASP.NET 2.0
- Excel Data Analysis
- Excel Pivot Tables
- Excel Programming
- JavaScript
- Mambo
- PHP & MySQL
- SEO

- Vista Sidebar
- Visual Basic
- XML

Visual Encyclopedia^{*}

Your A to Z reference of tools and techniques. Full color.

- Dreamweaver
- Excel
- Mac OS

- Photoshop
- Windows

Visual Quick Tips

Shortcuts, tricks, and techniques for getting more done in less time. Full color.

- Crochet
- Digital Photography
- Excel
- iPod & iTunes
- Knitting
- MySpace
- Office
- PowerPoint
- Windows
- Wireless
 - Networking

For a complete listing of Visual books, go to wiley.com/go/visual

,